Coloring book

ILLUSTRATOR
OLGA GOLOVESHKINA

Alice in Wonderland

Copyright © 2017 Olga Goloveshkina

All rights reserved.

ISBN: 1544883978
ISBN-13:9781544883977

Happy coloring

Thank you for choosing my coloring book!

Olya :)

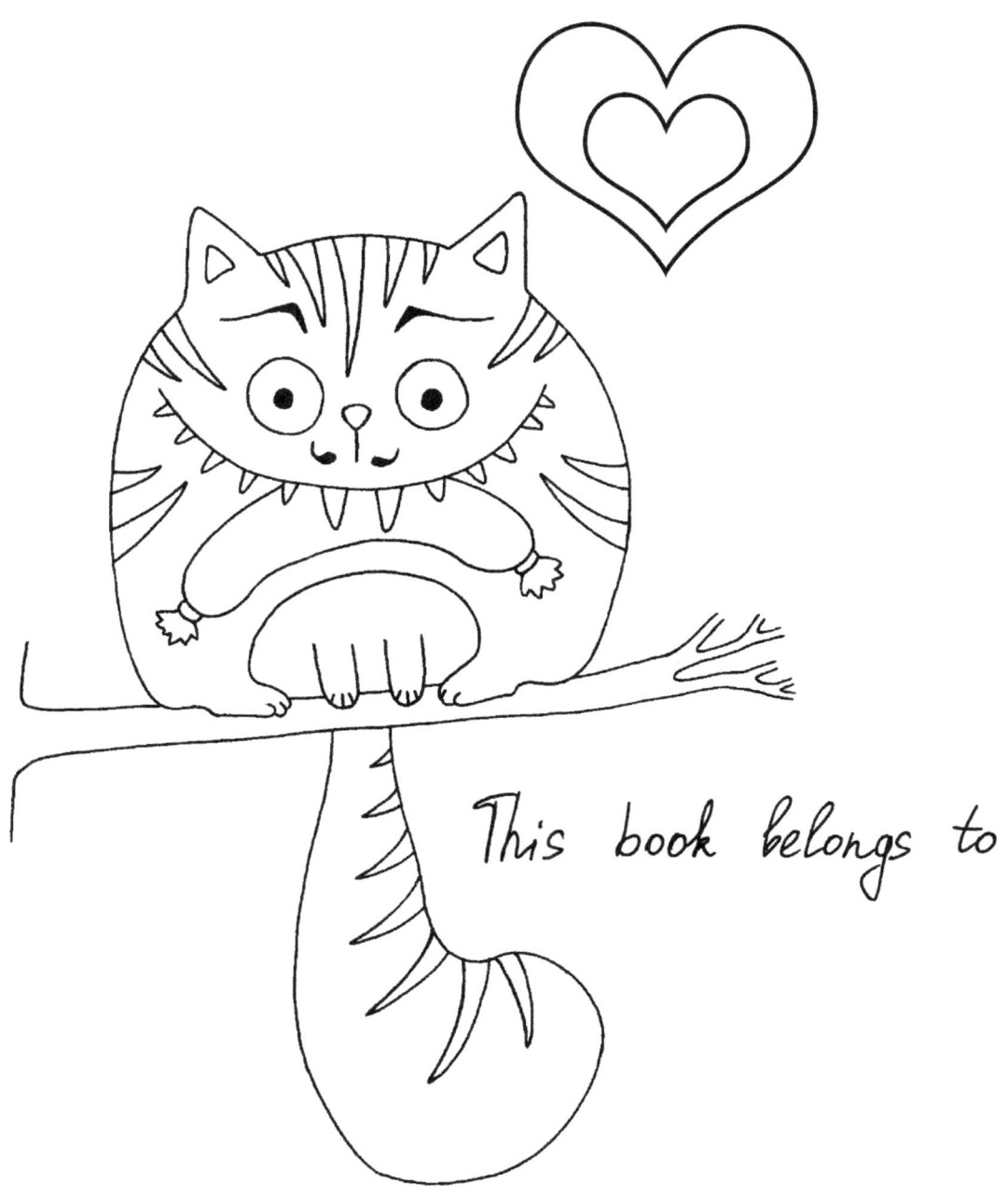

This book belongs to

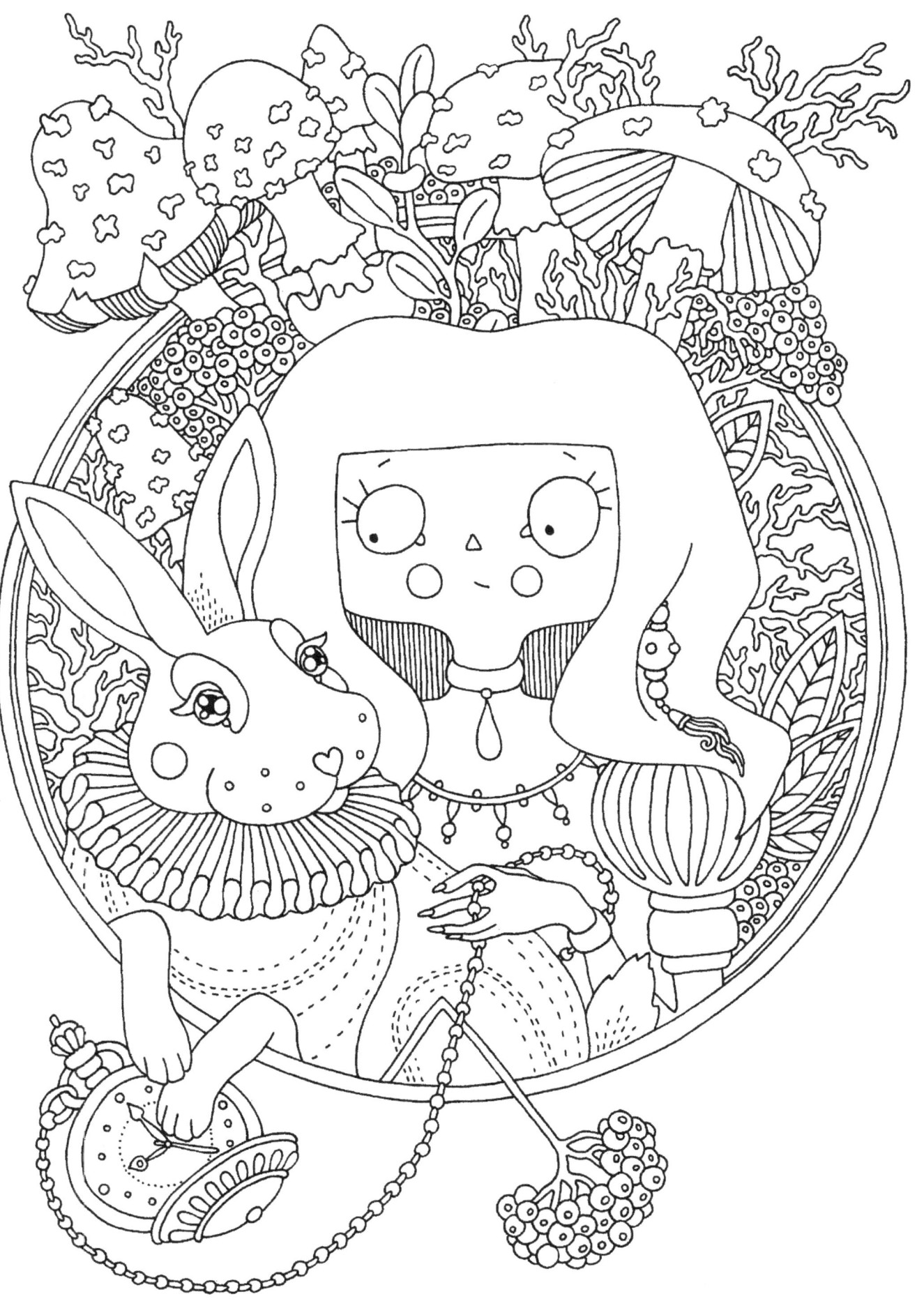

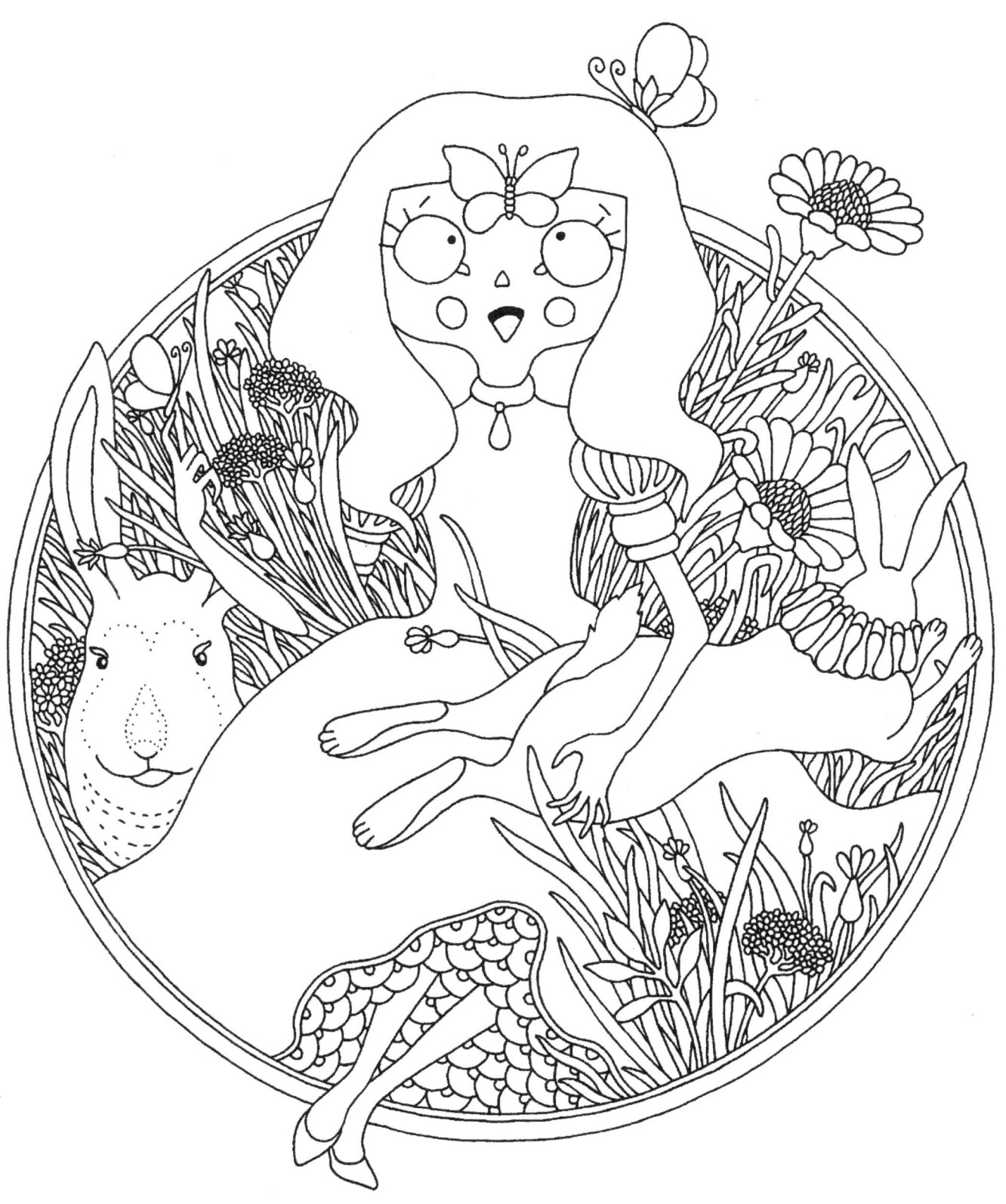

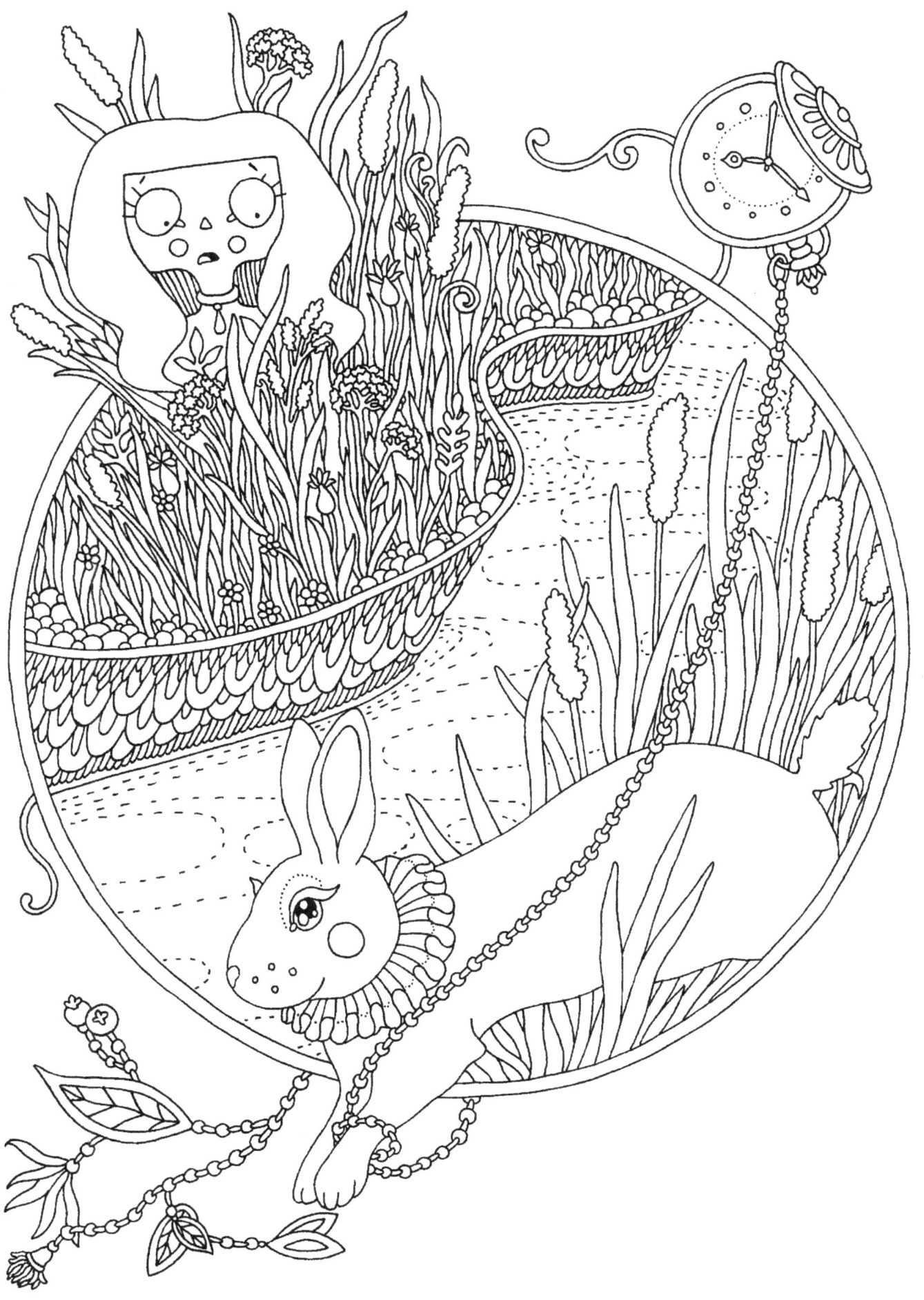

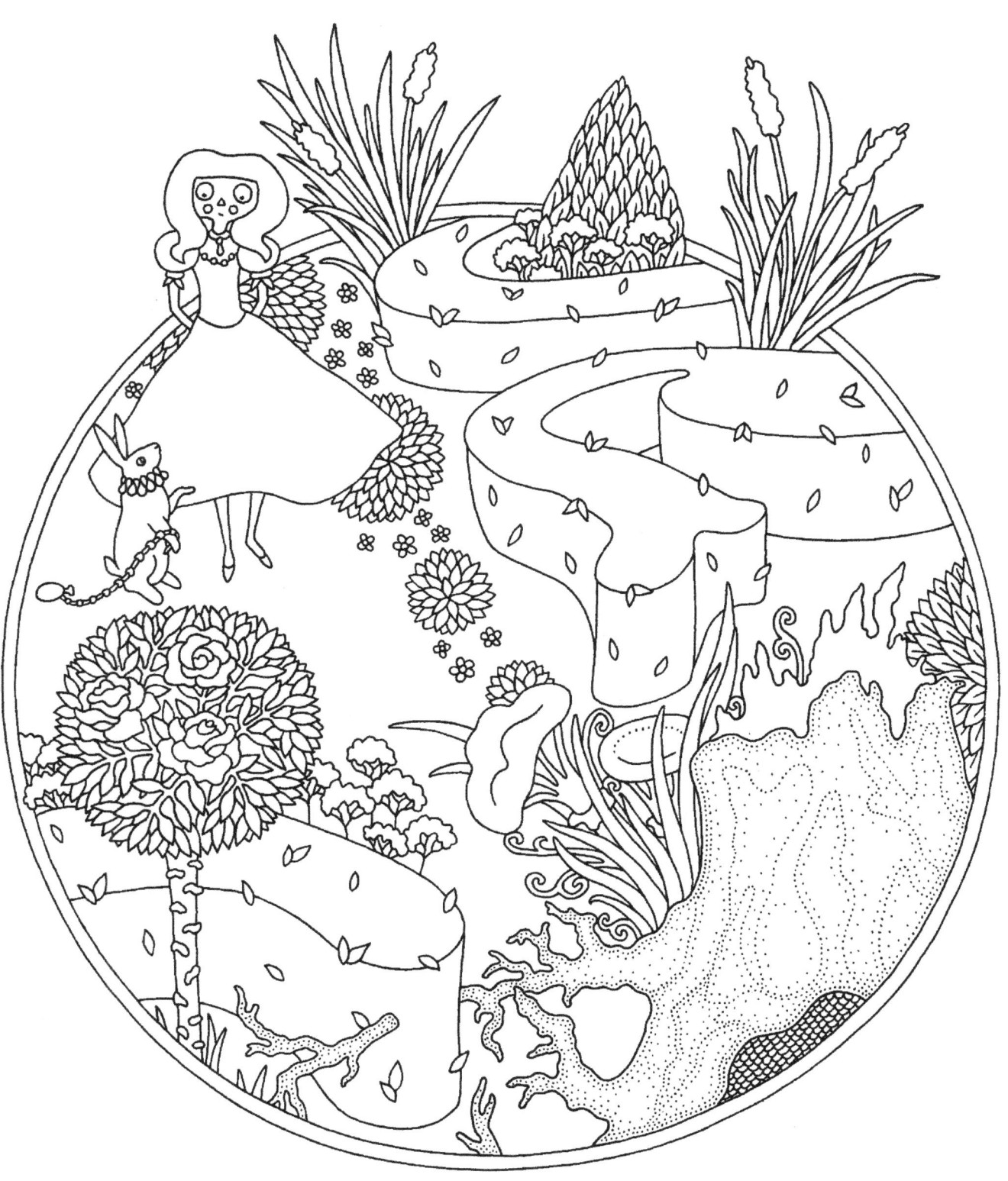

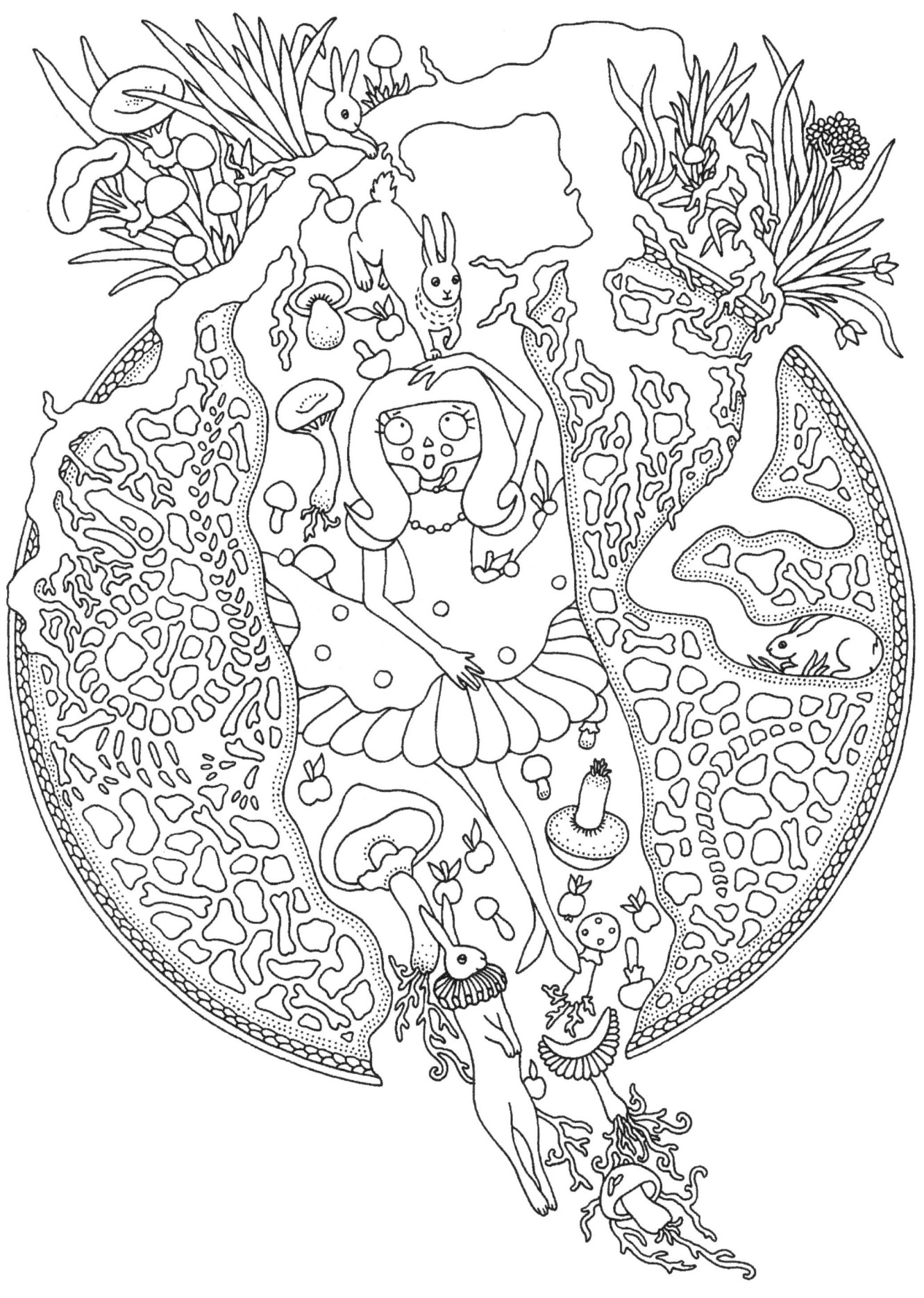

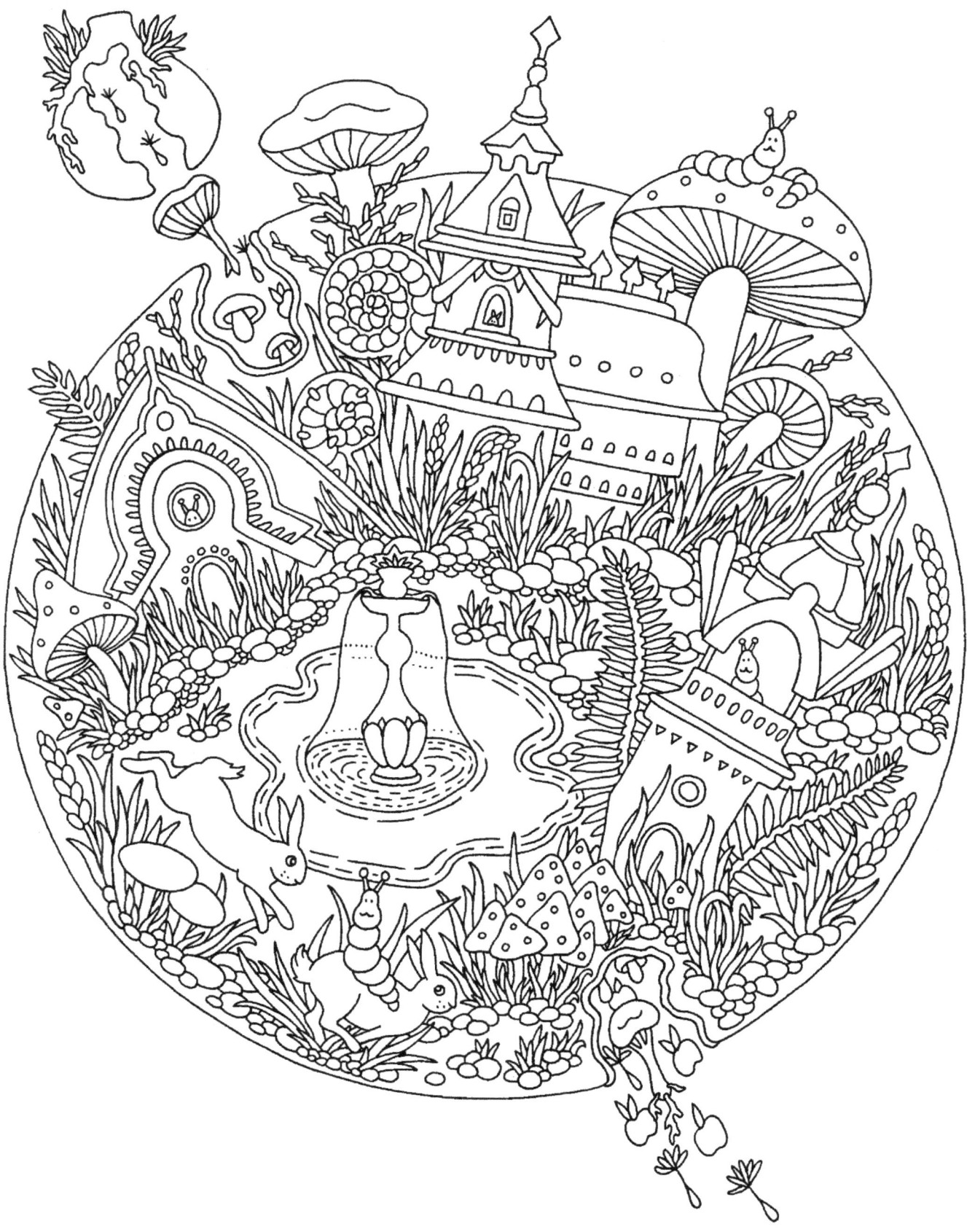

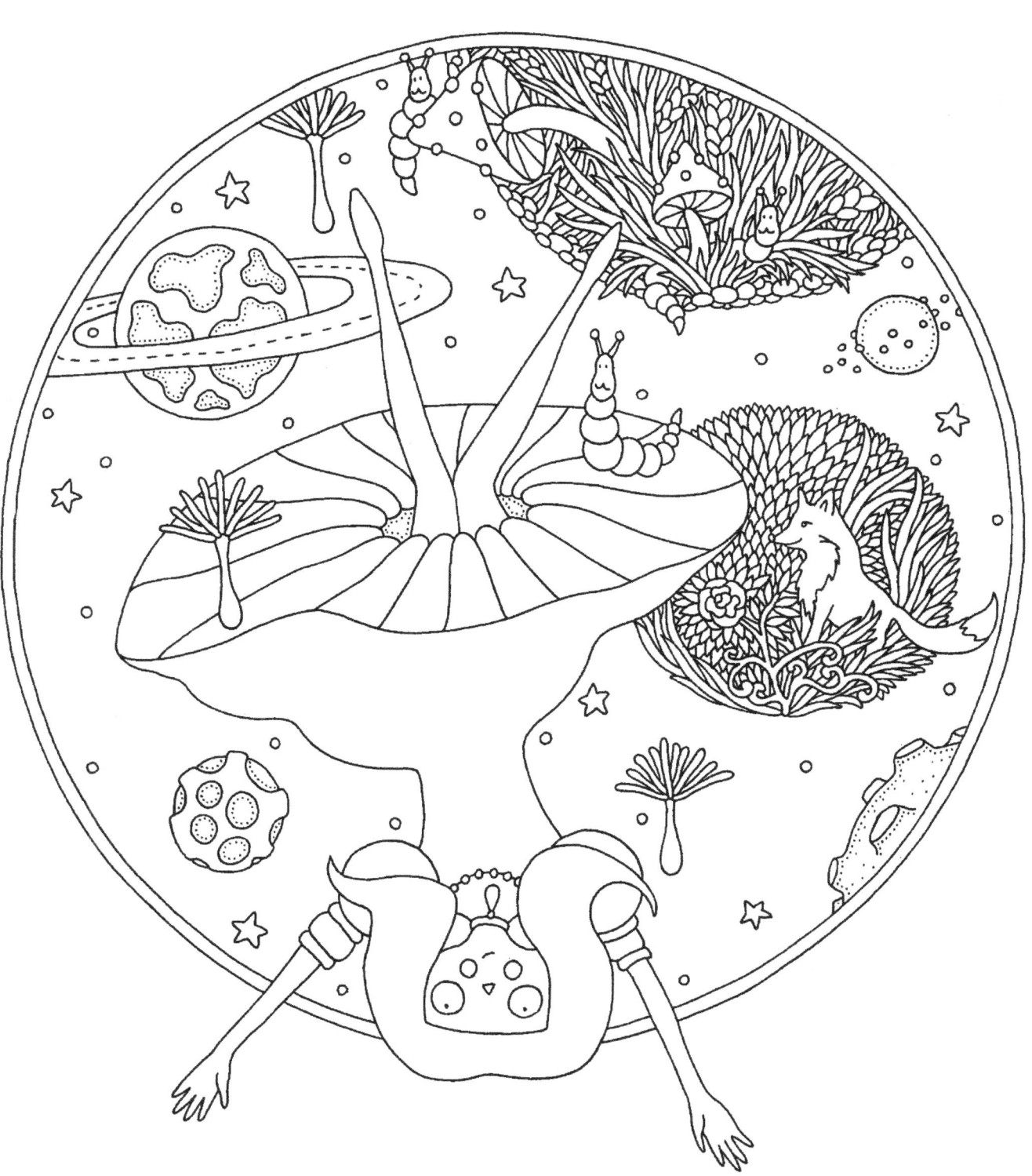

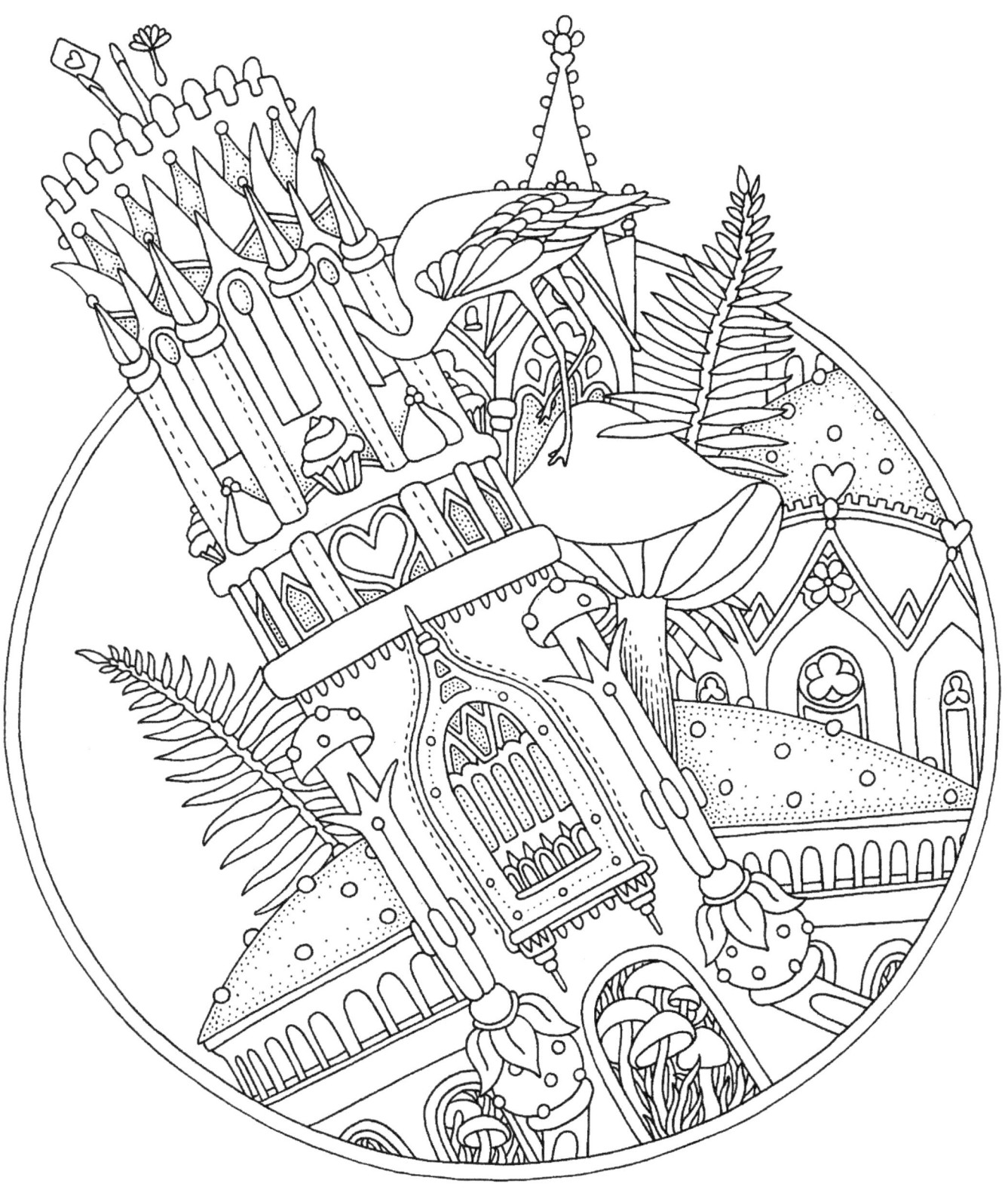

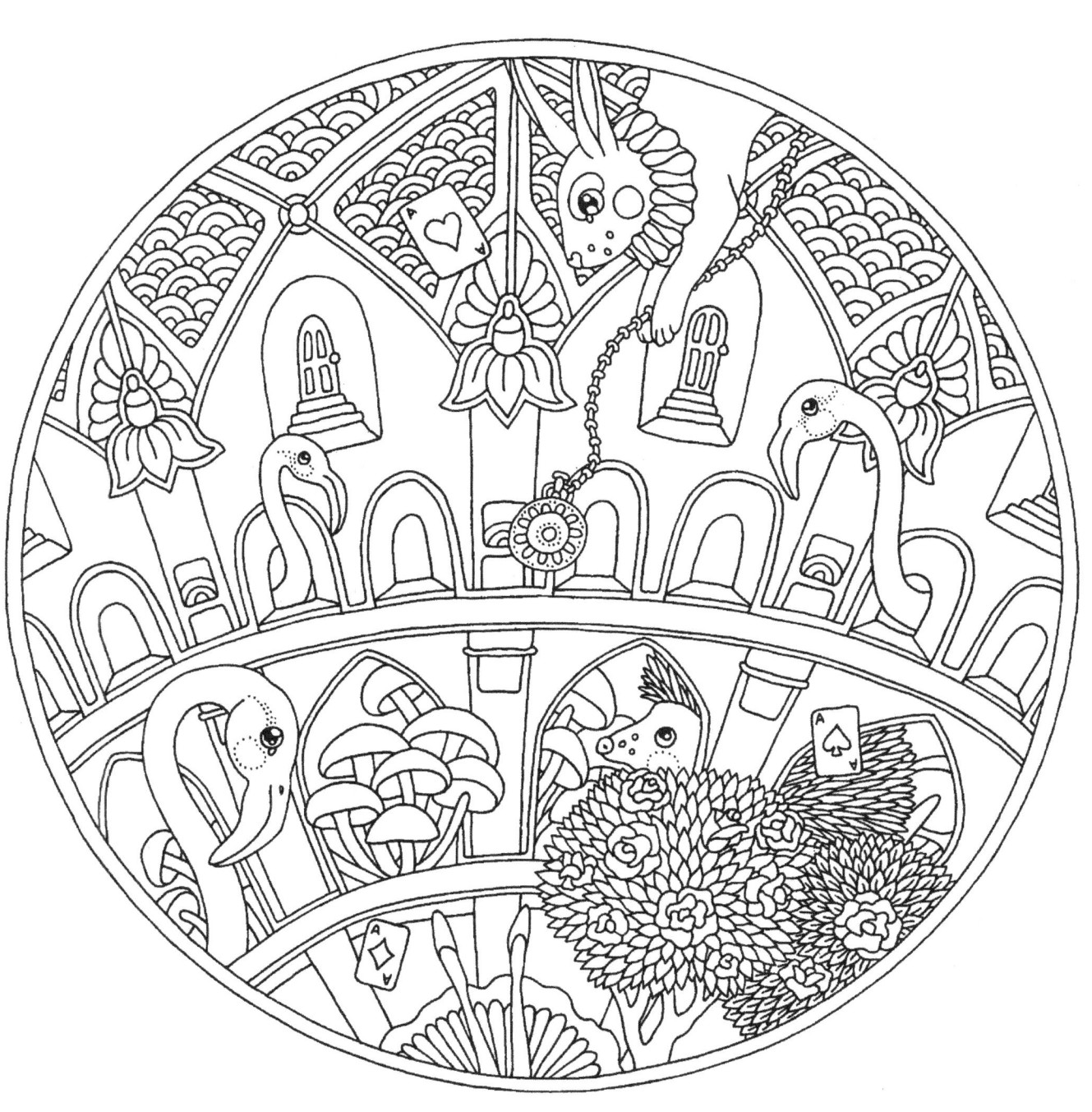

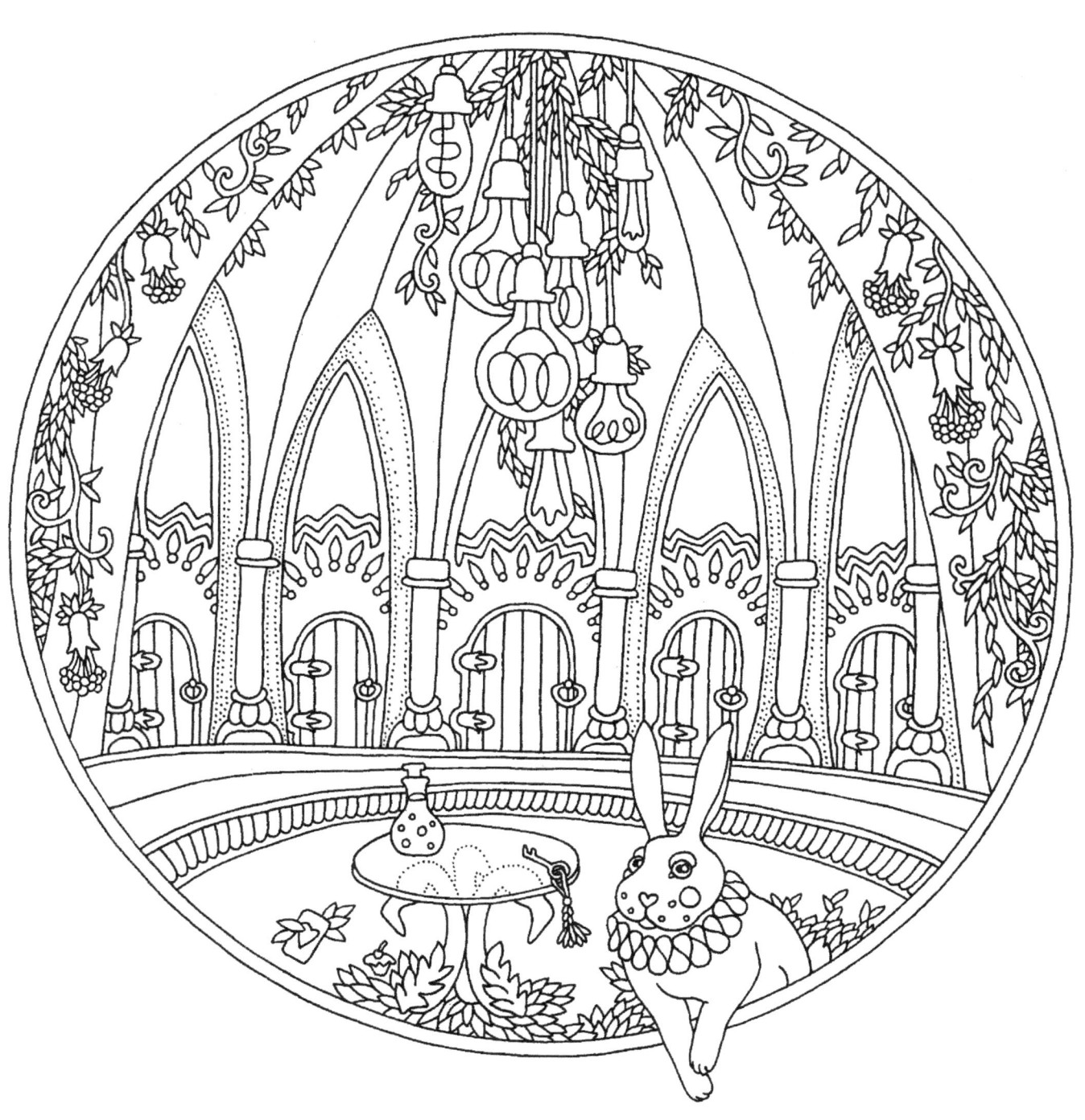

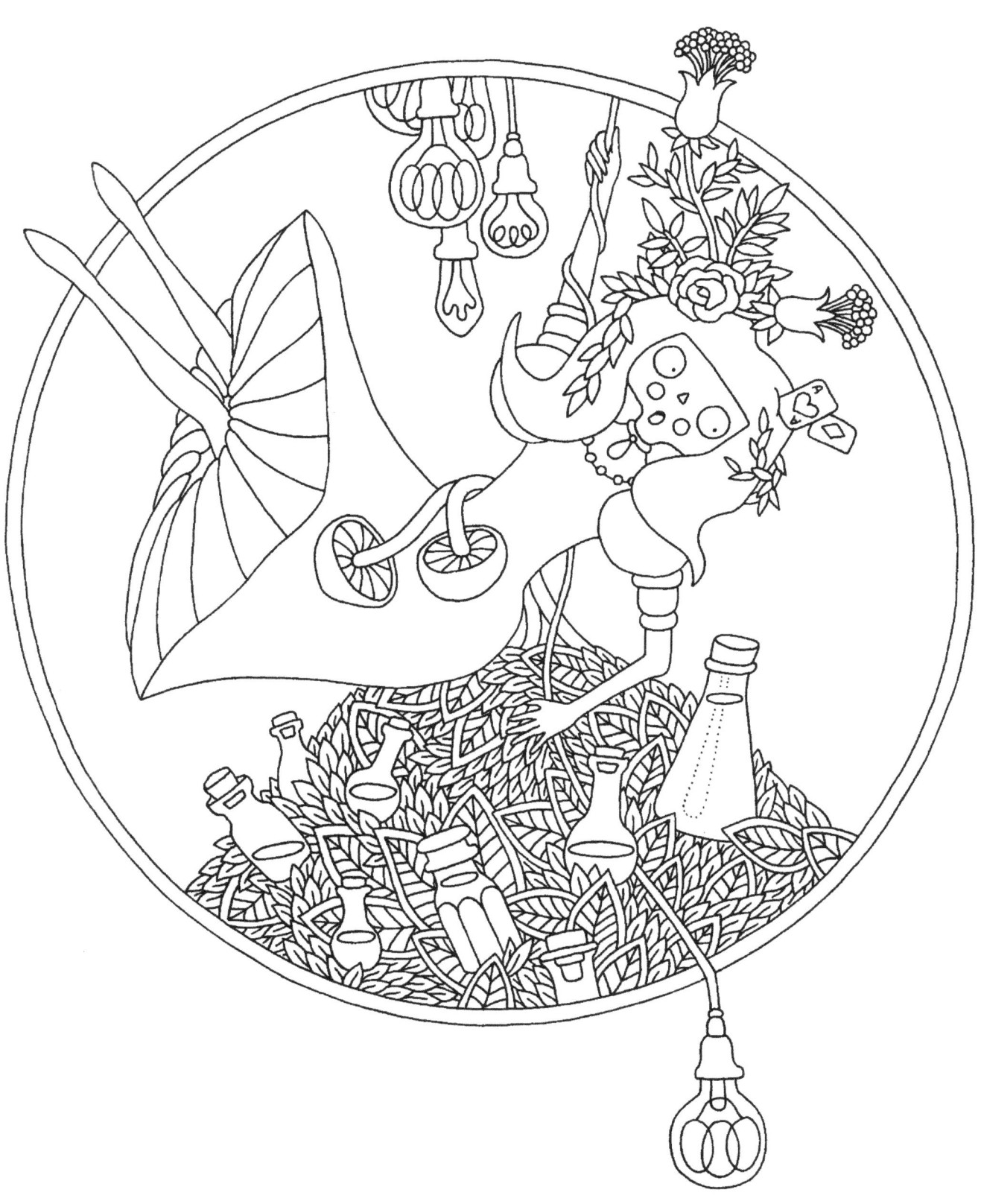

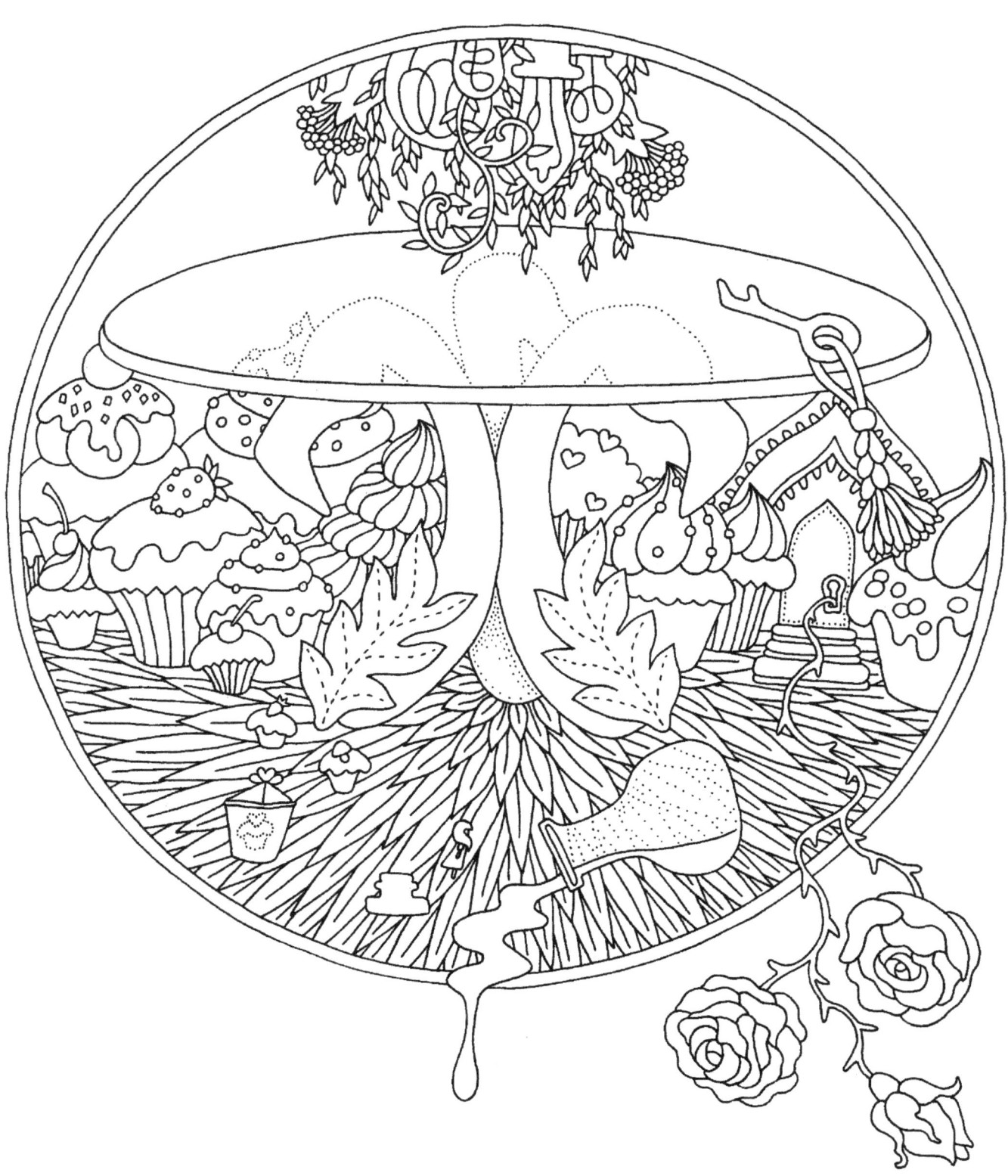

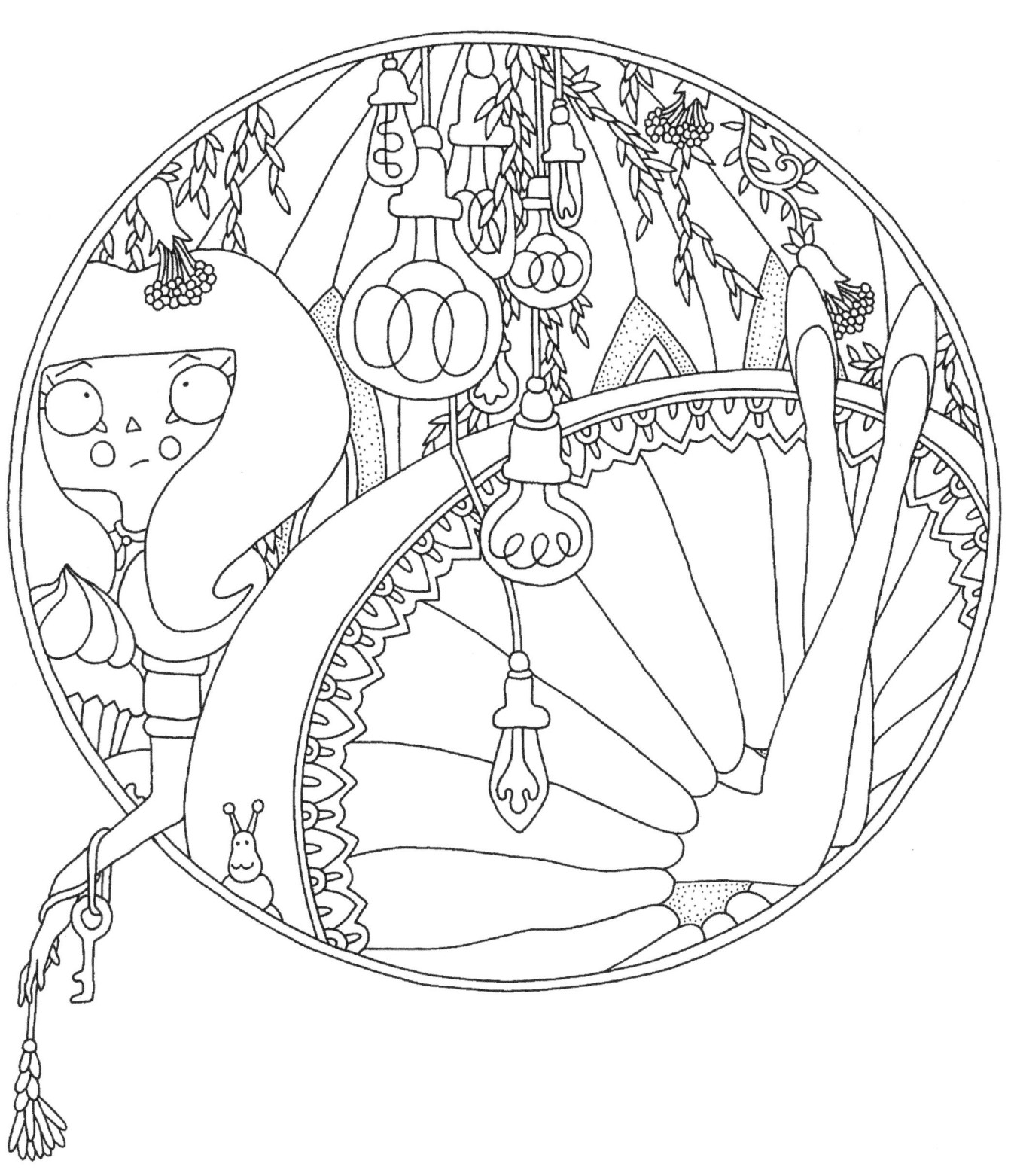

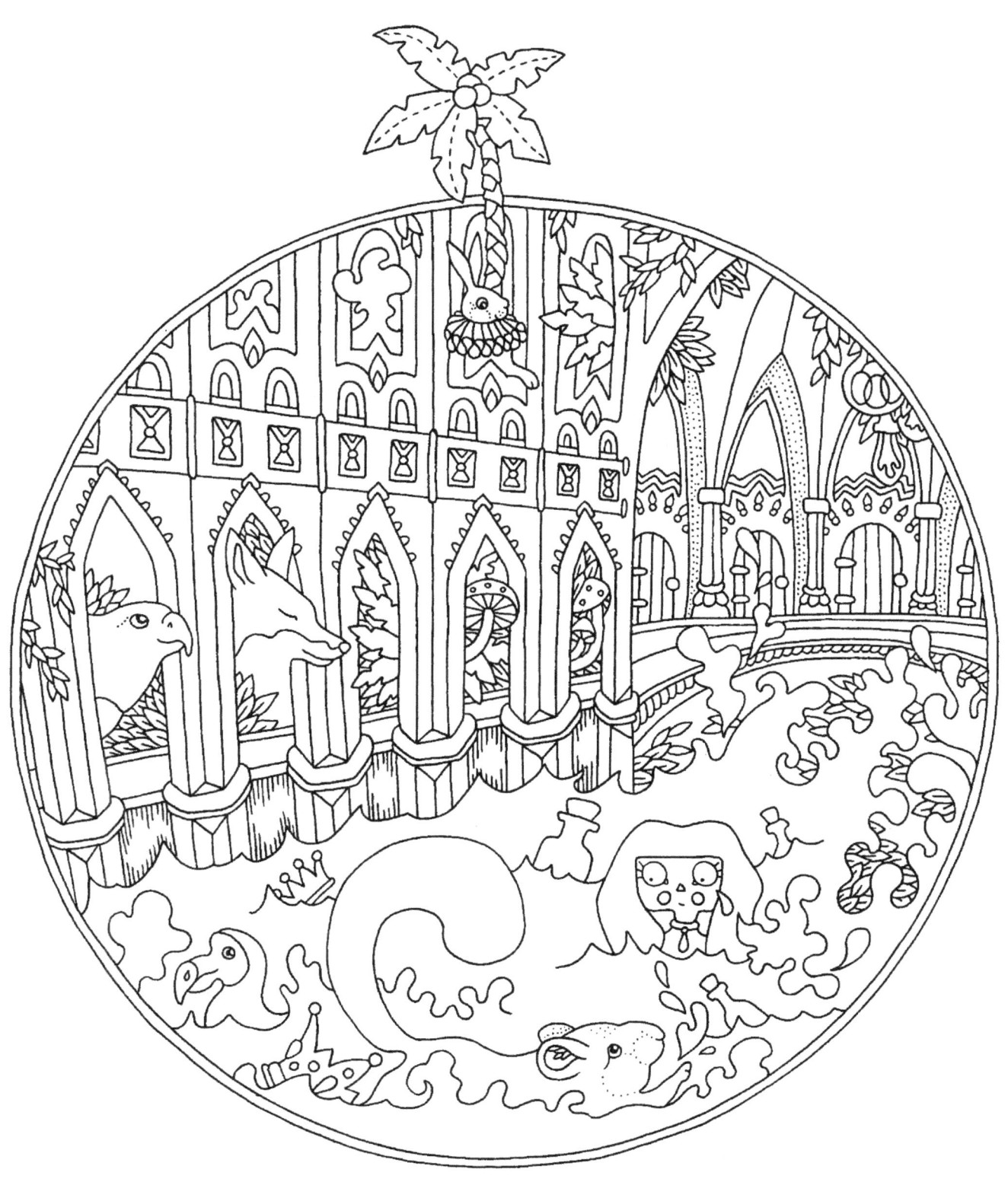

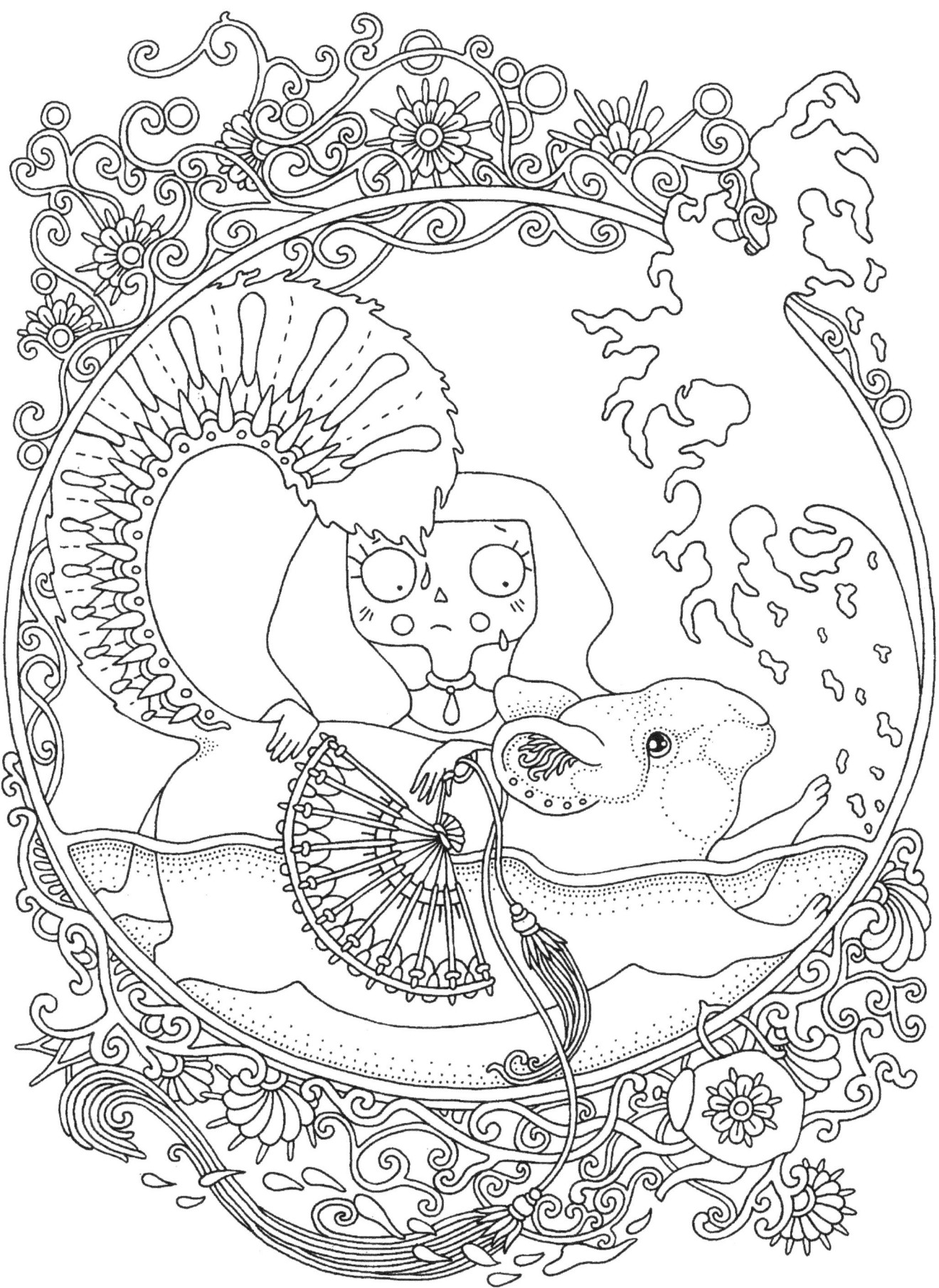

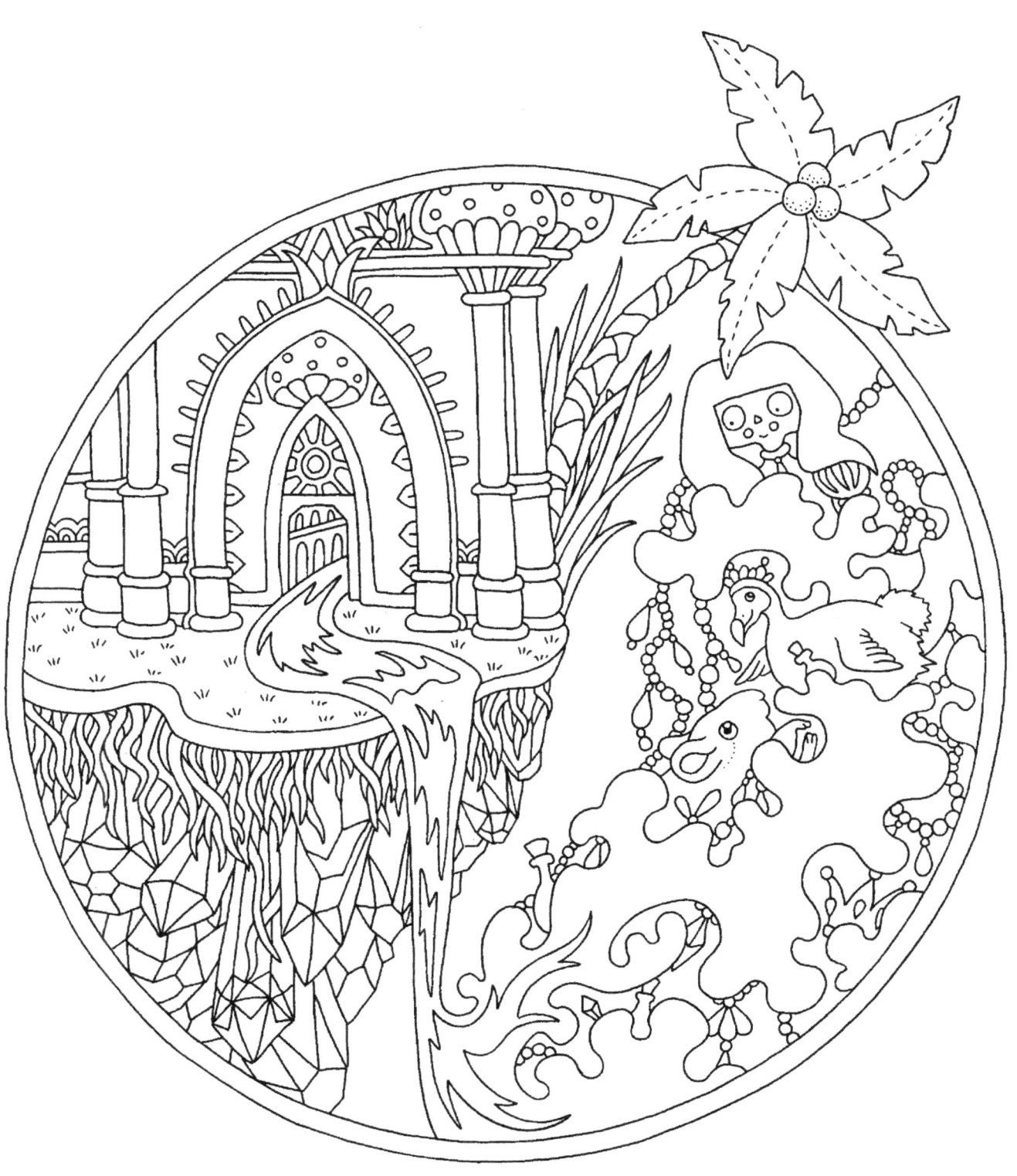

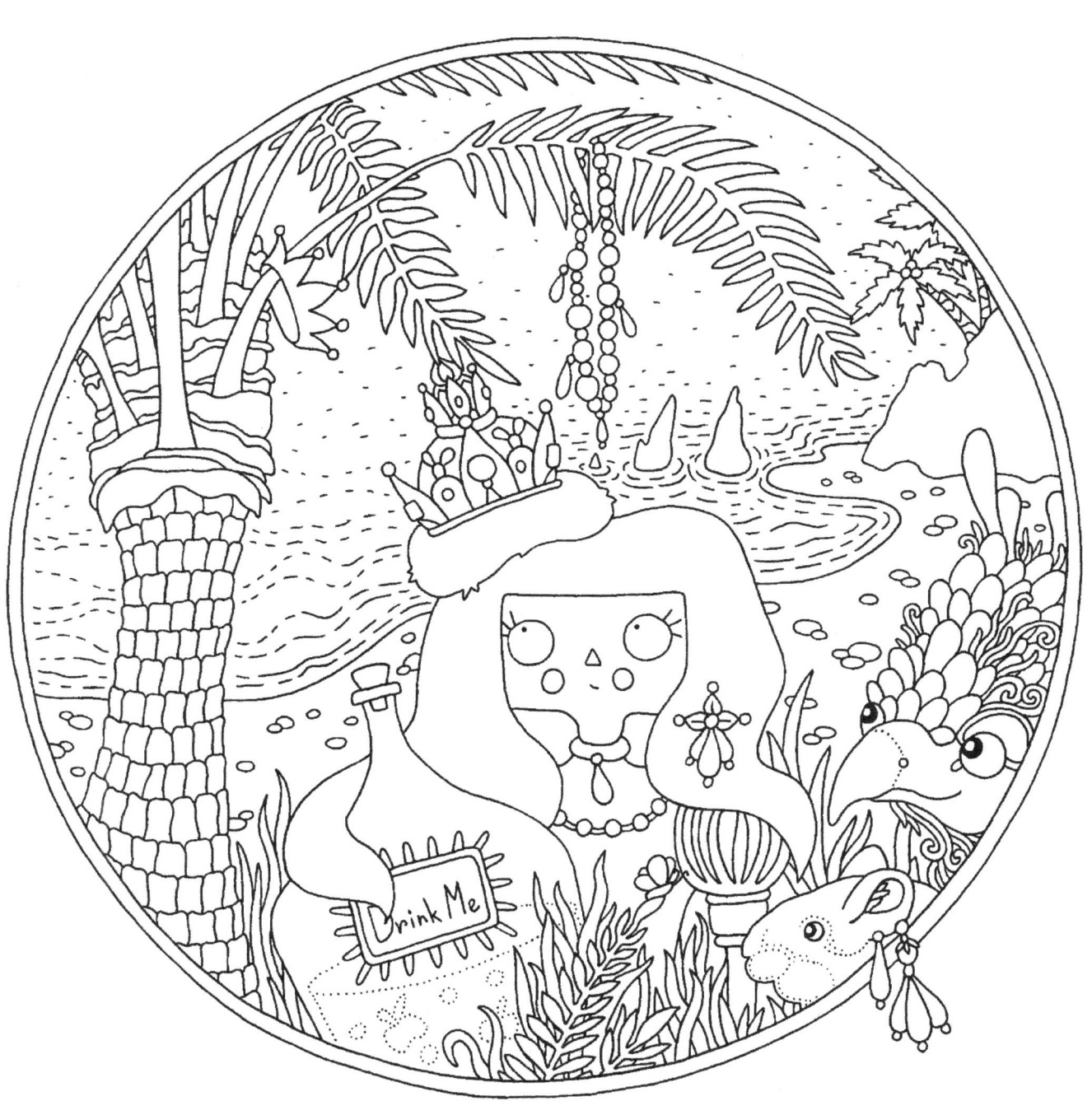

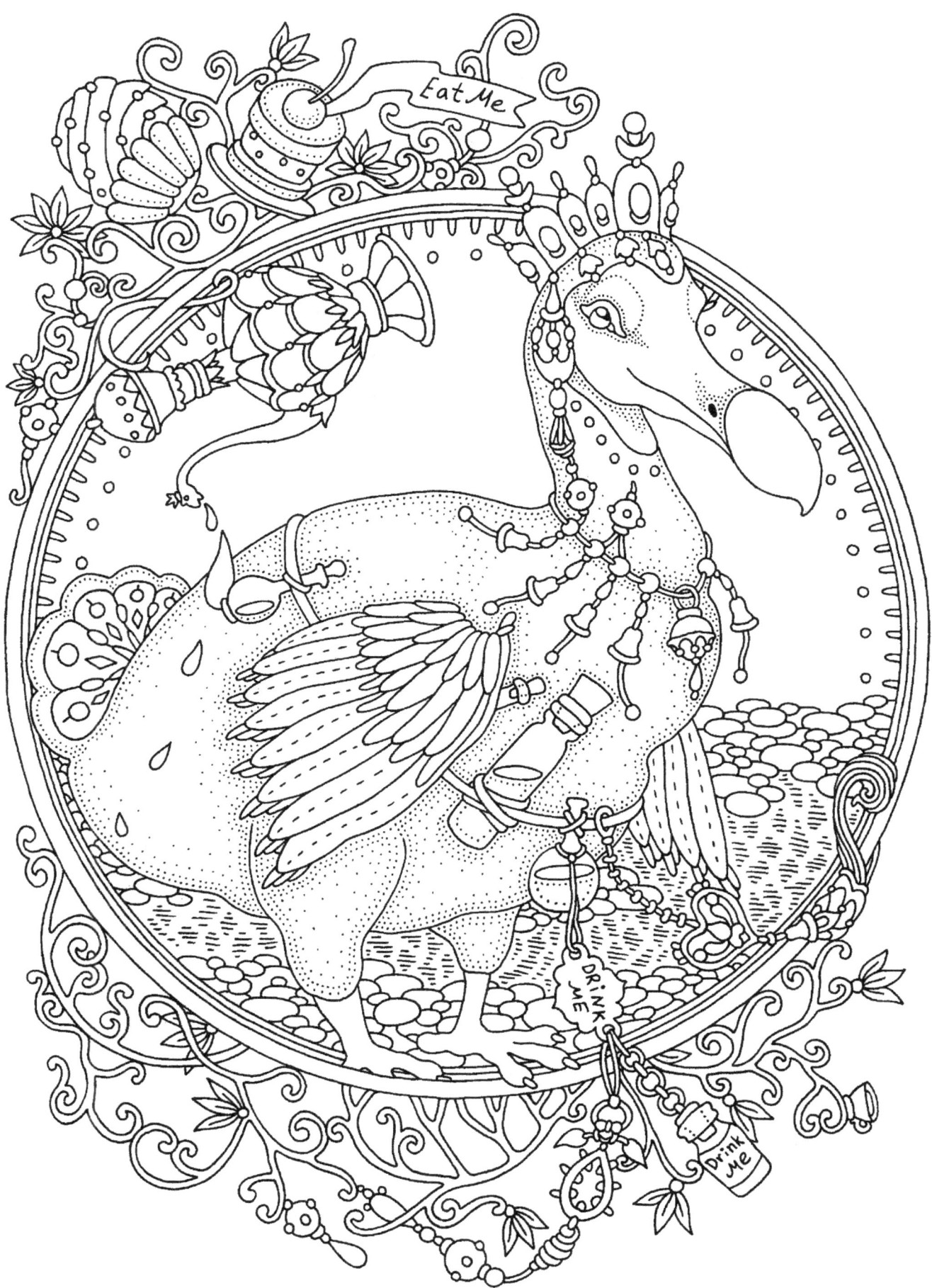

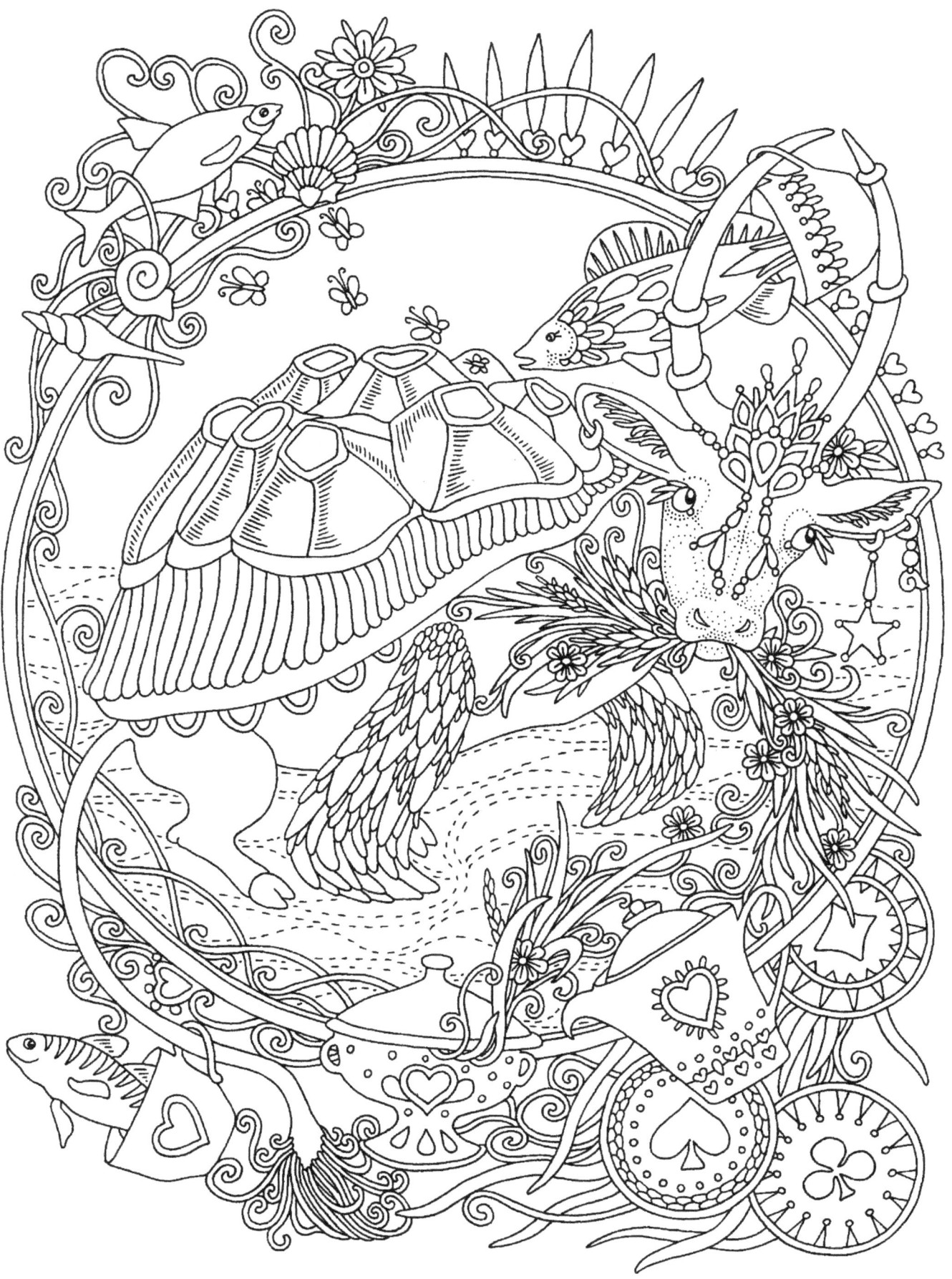

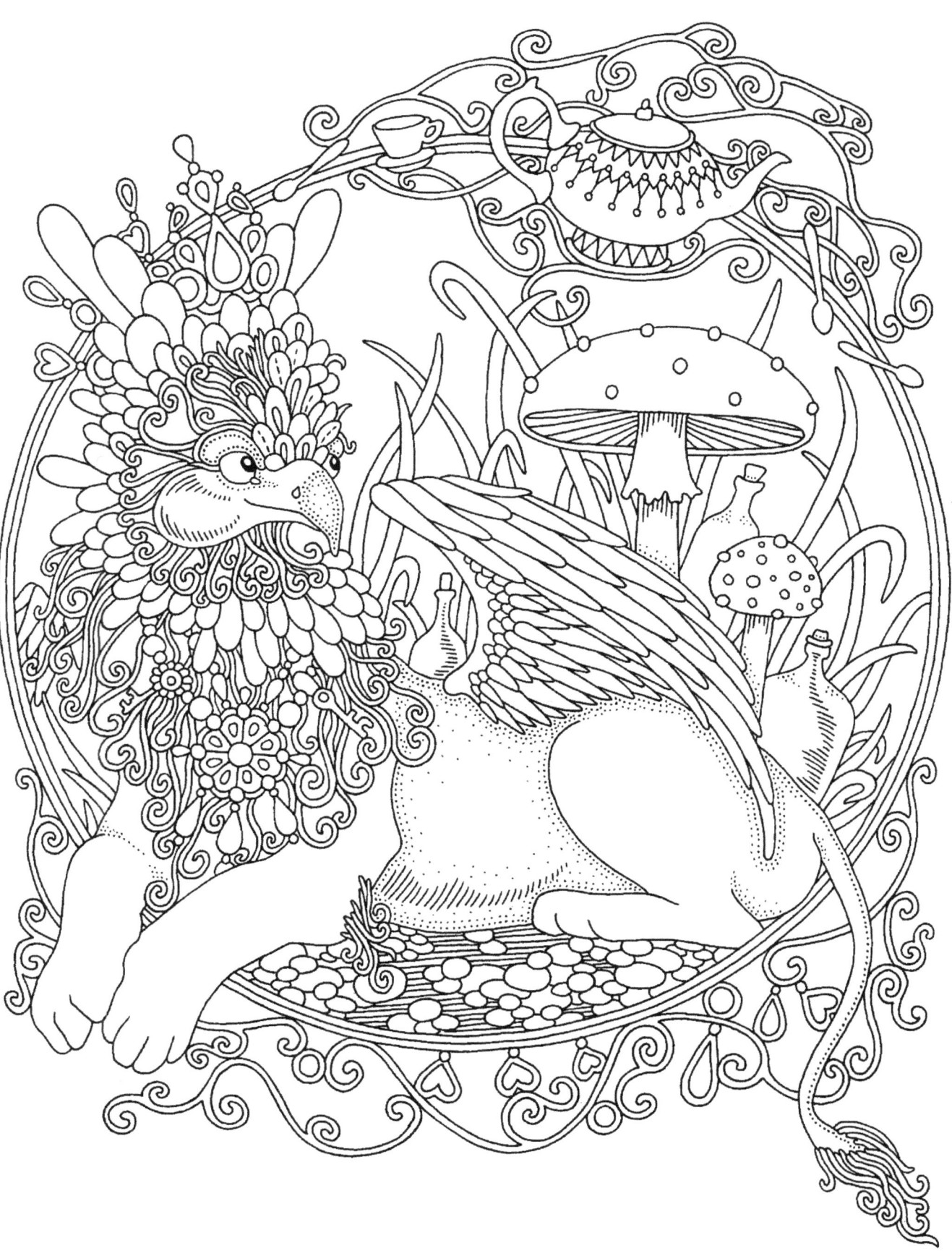

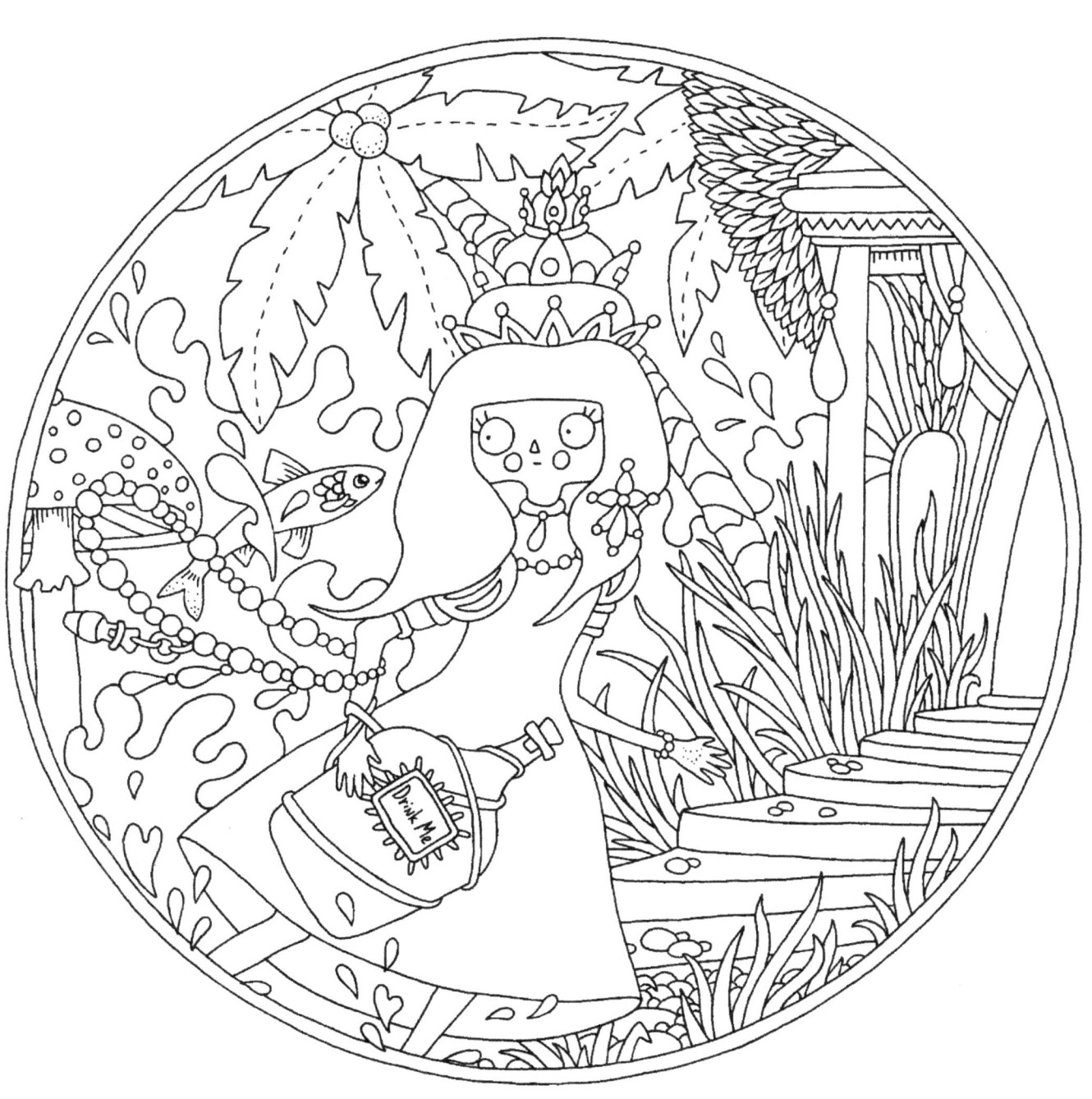

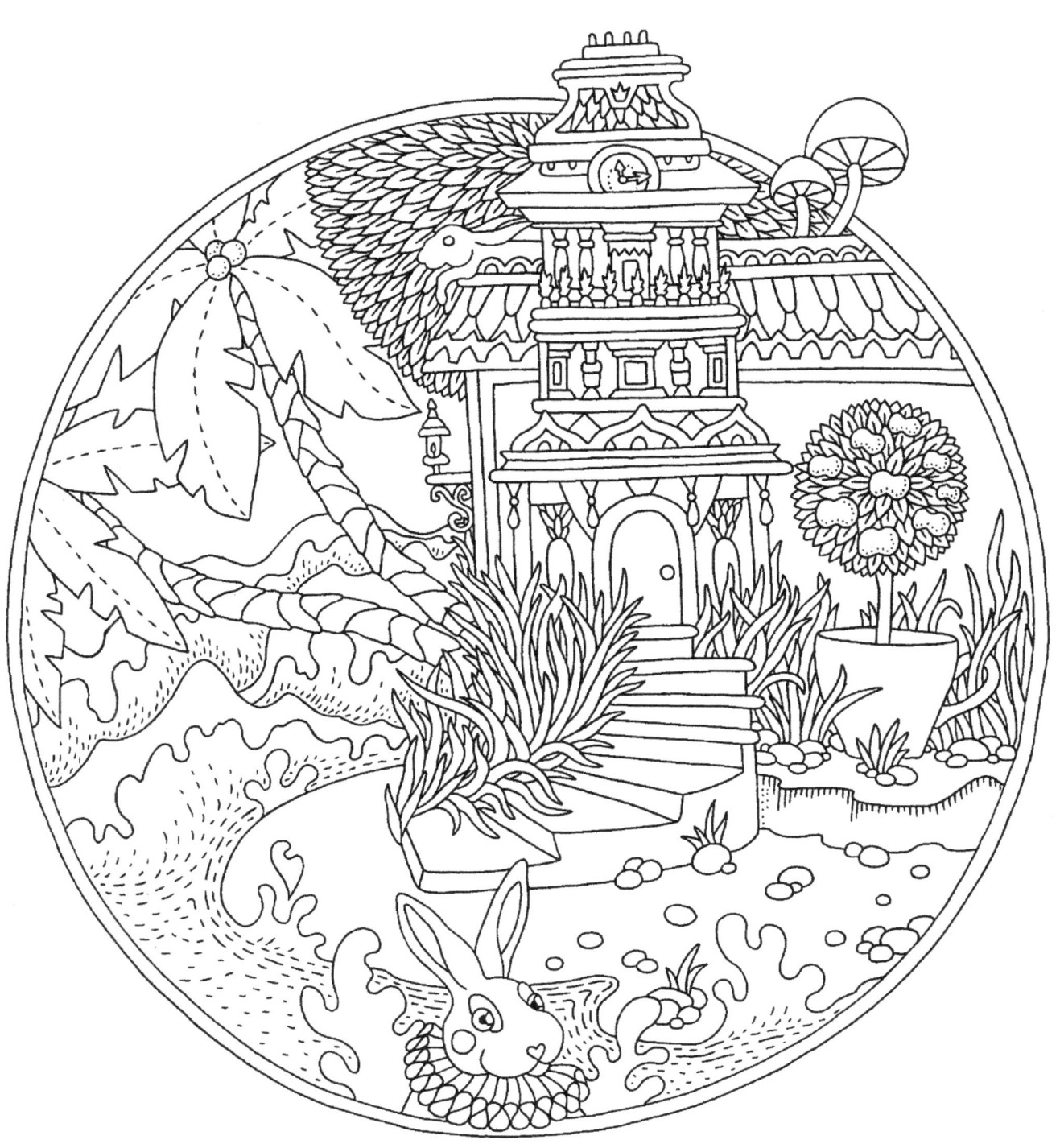

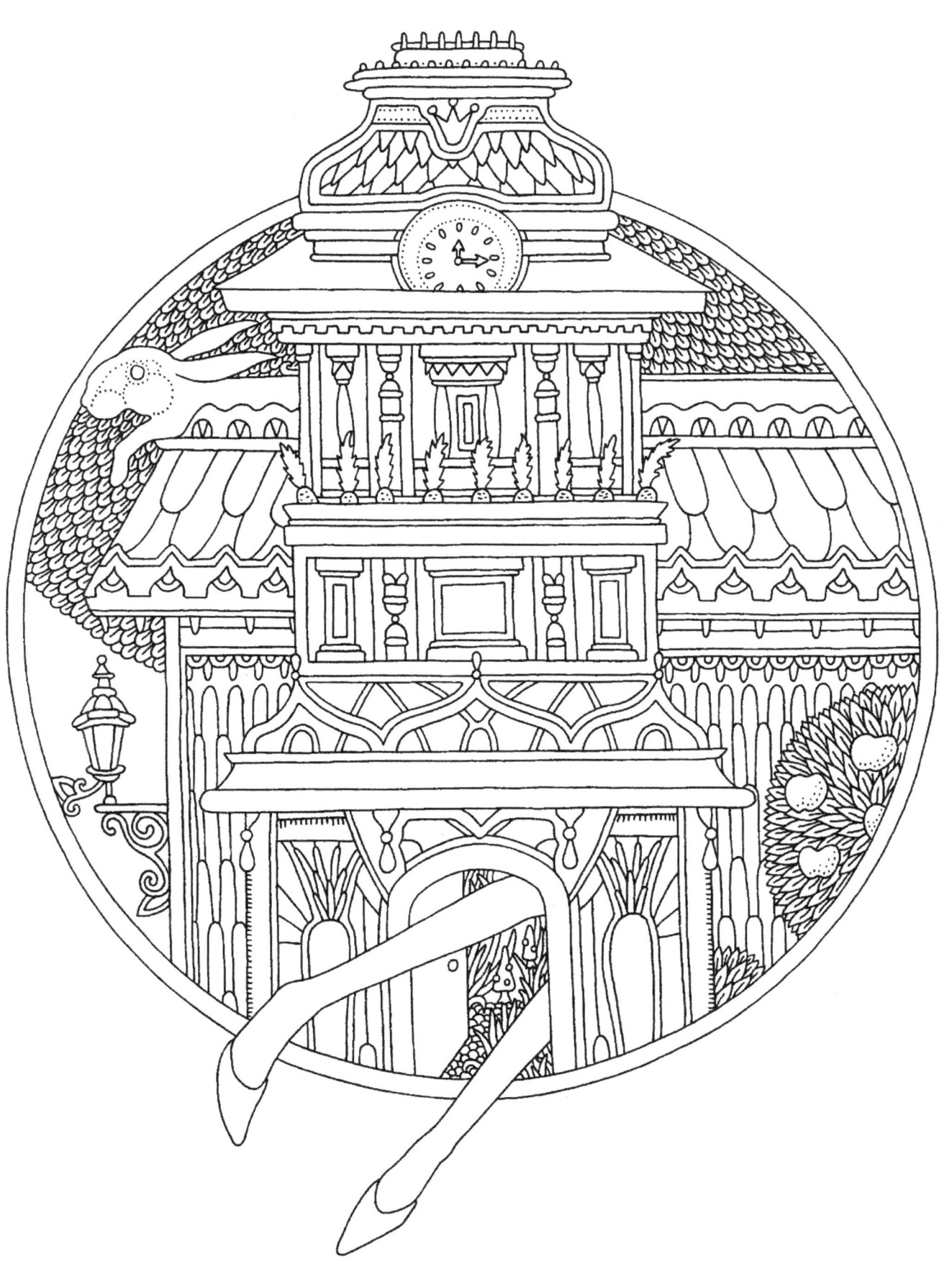

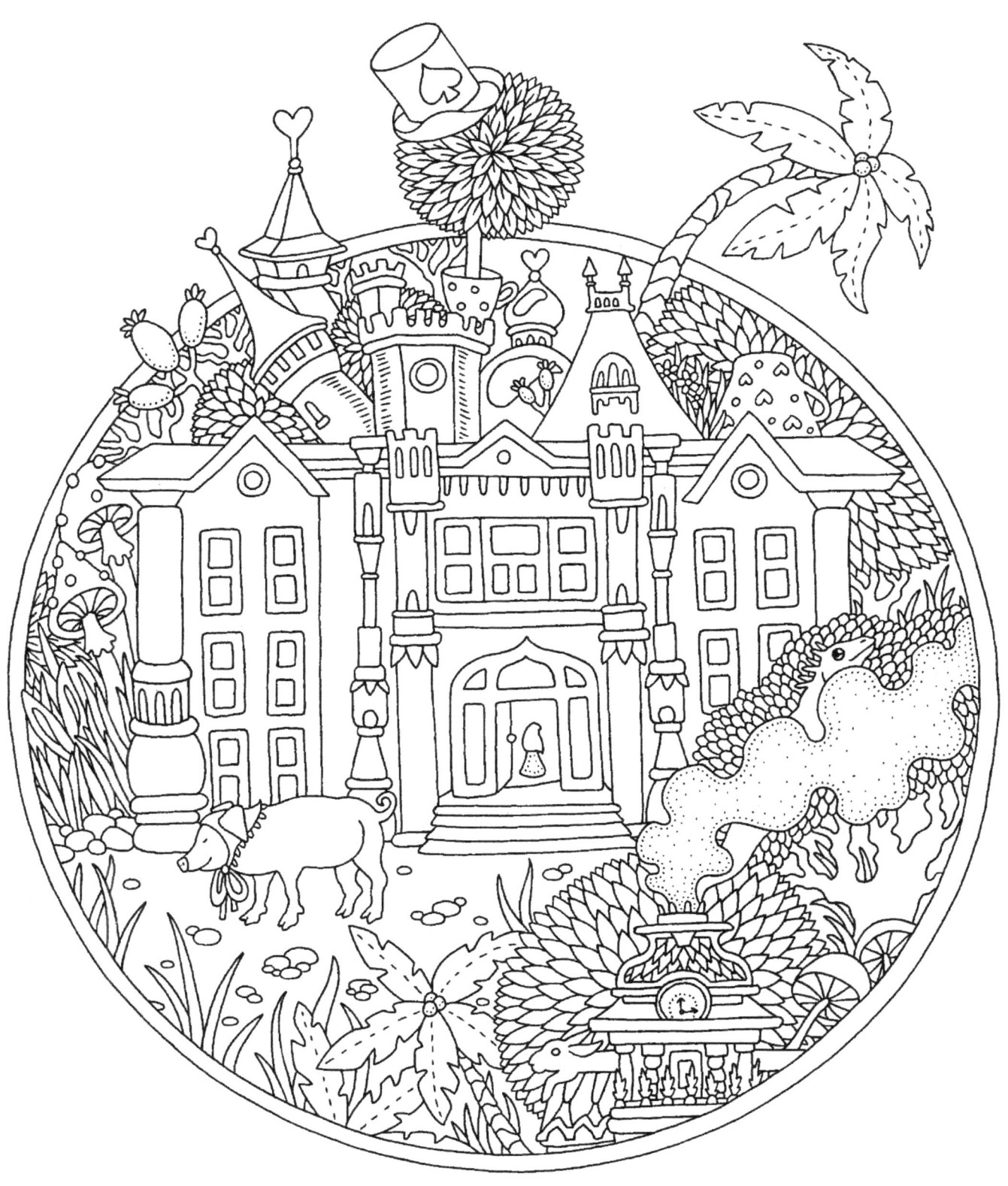

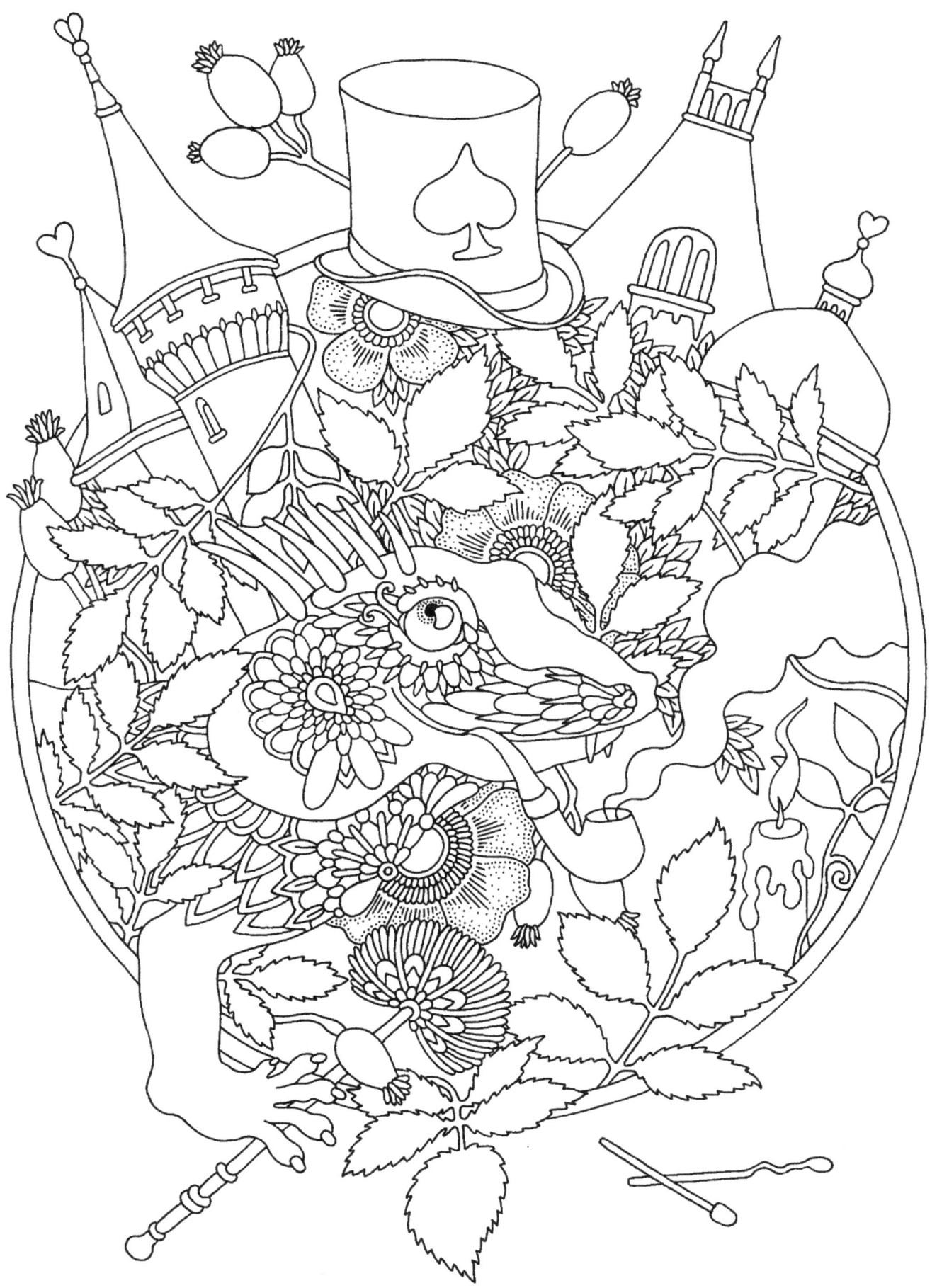

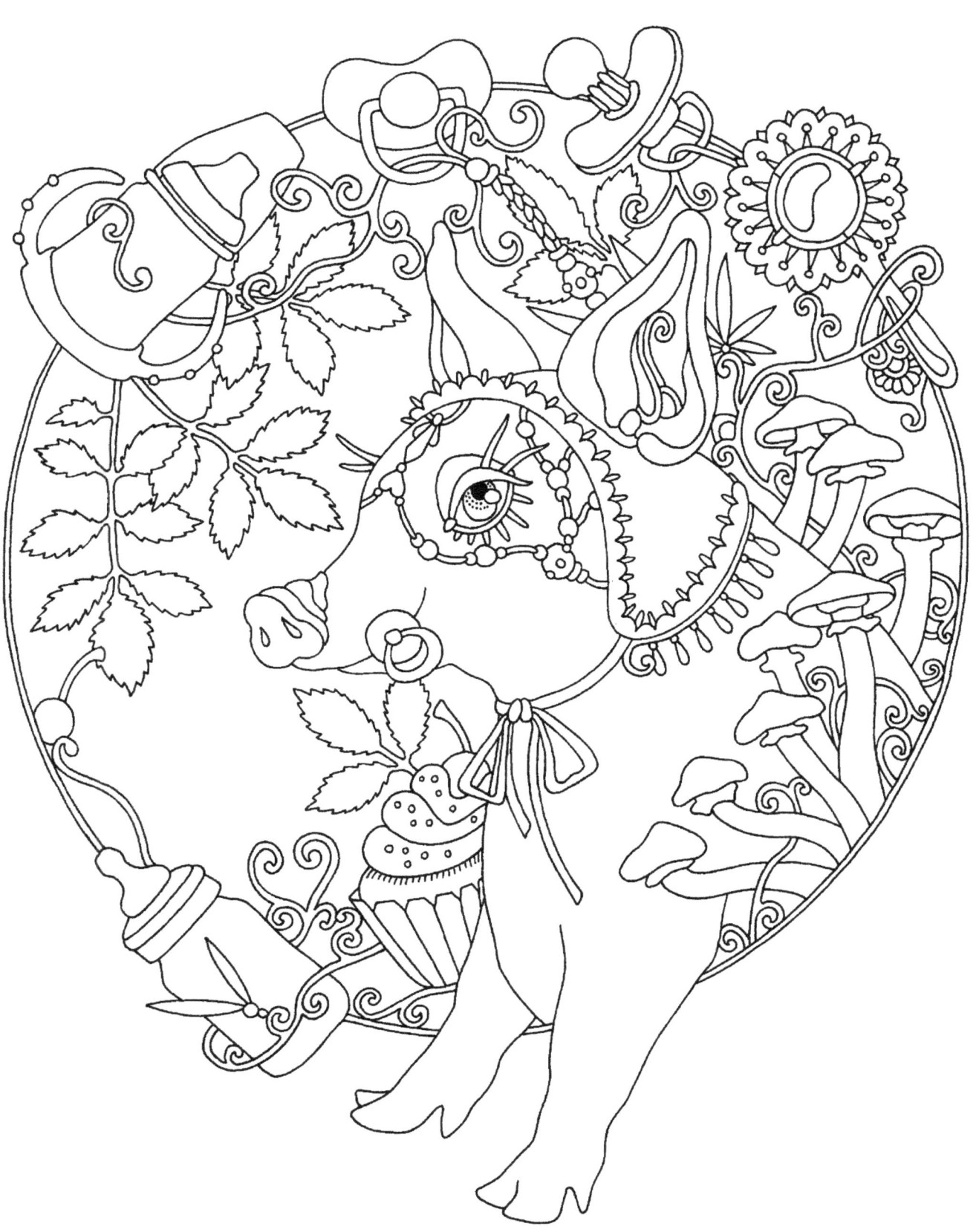

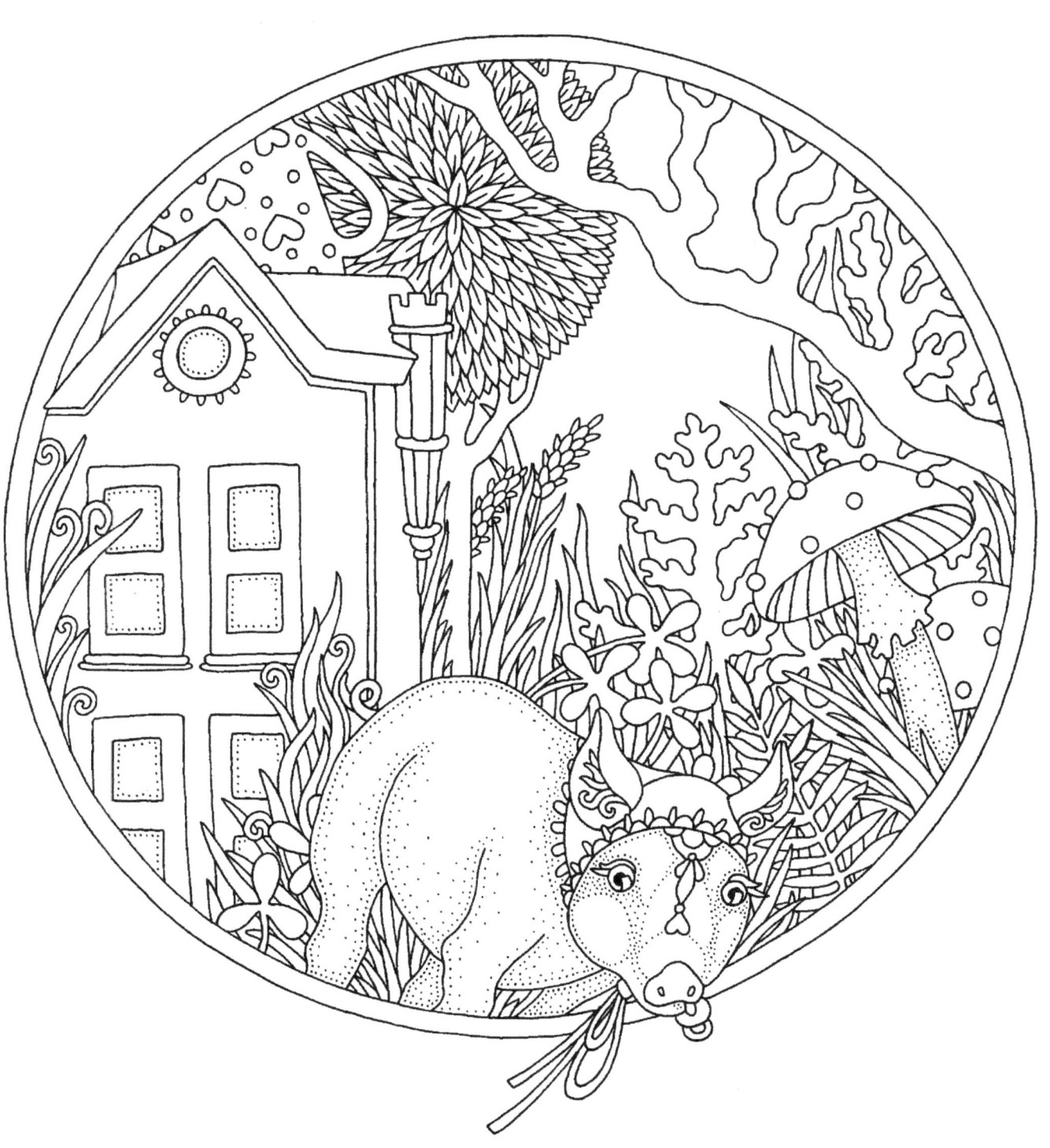

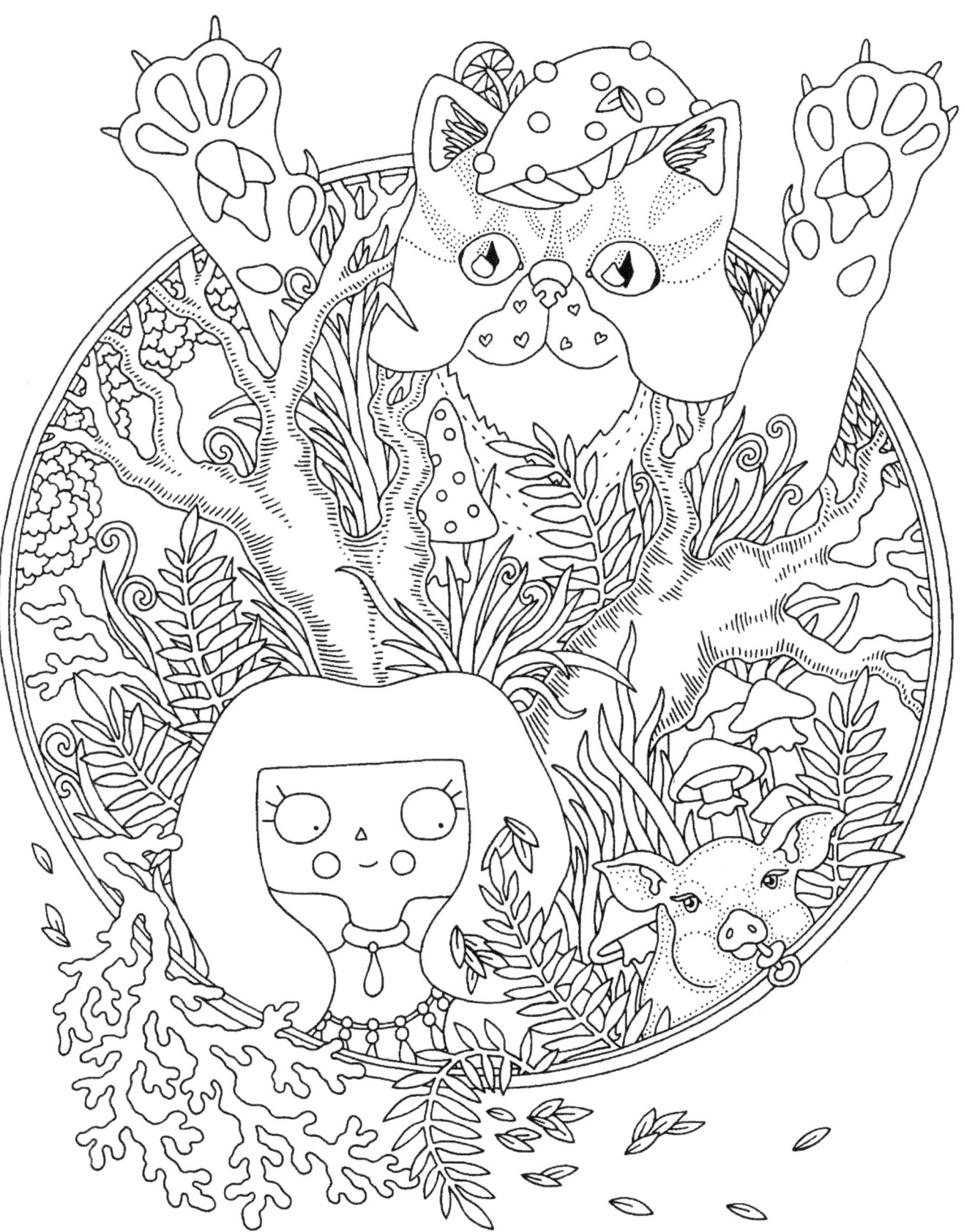

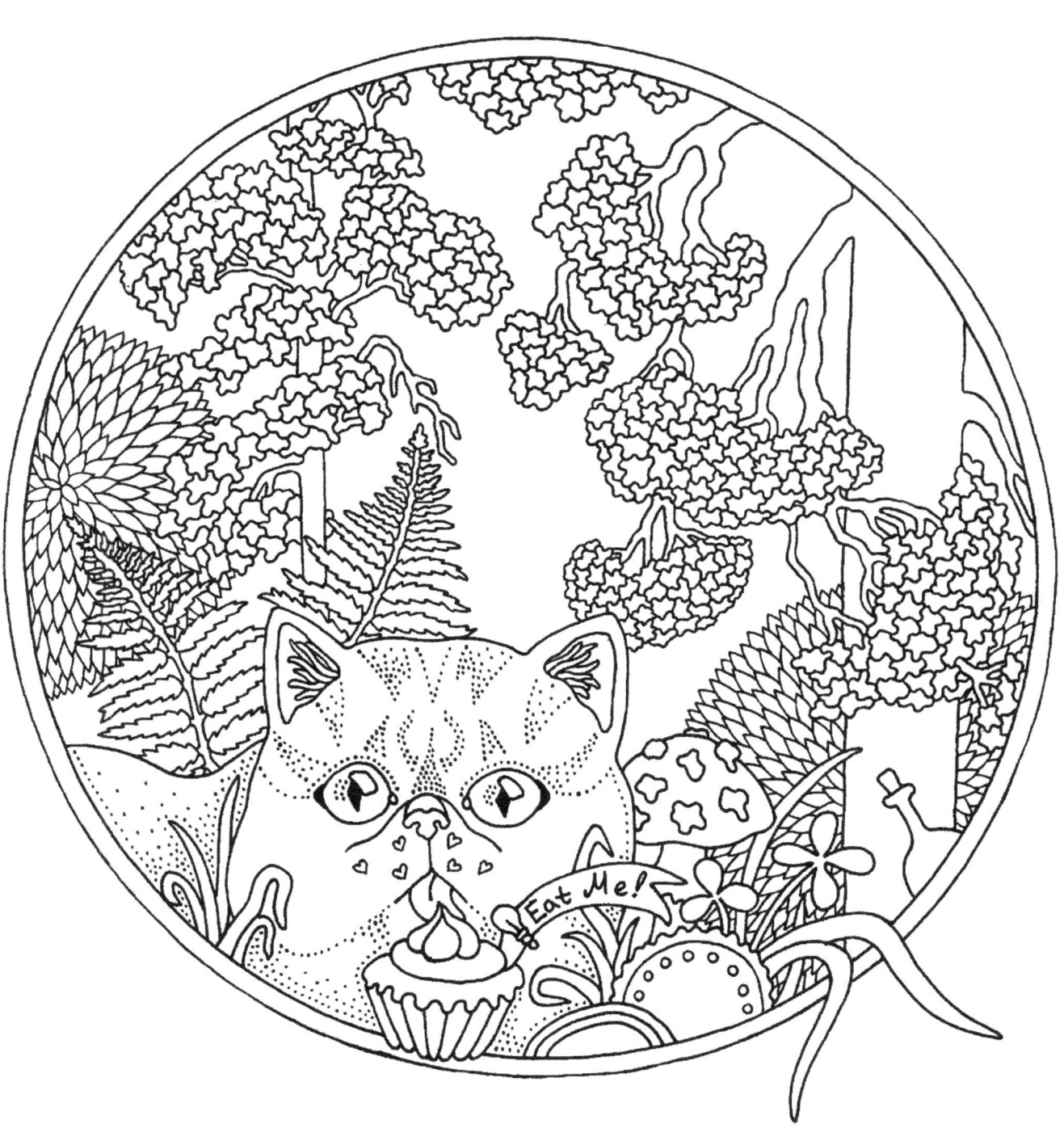

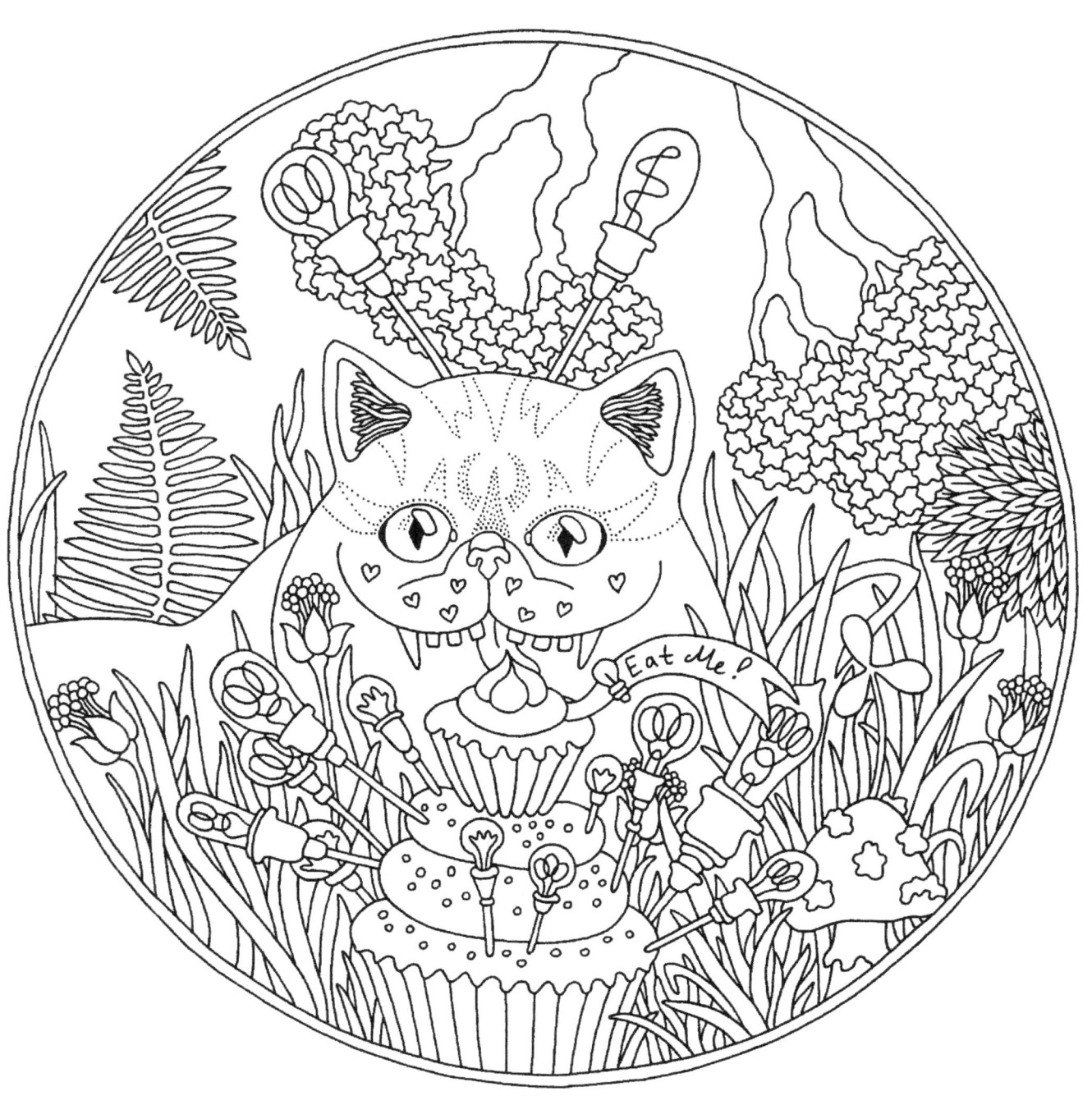

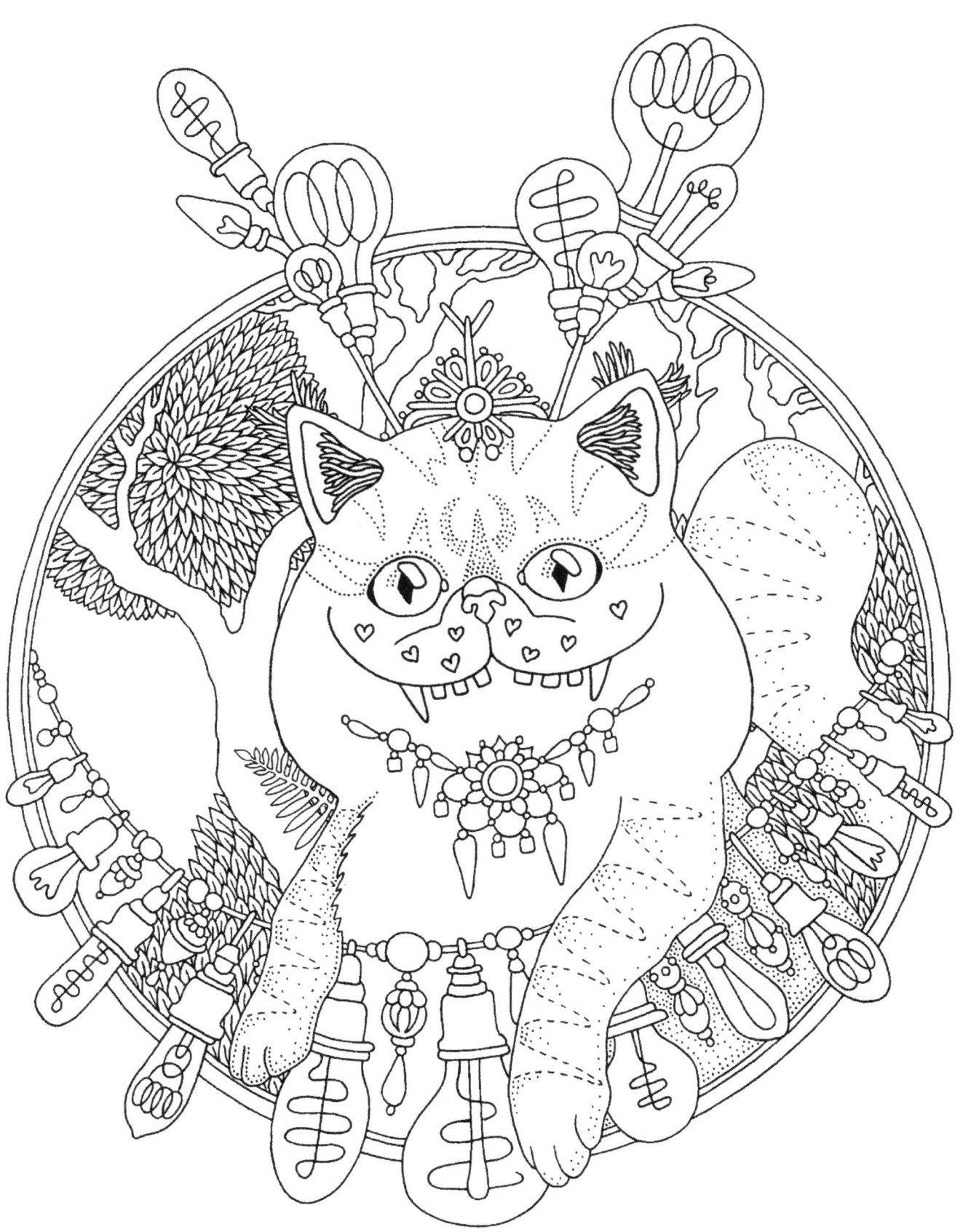

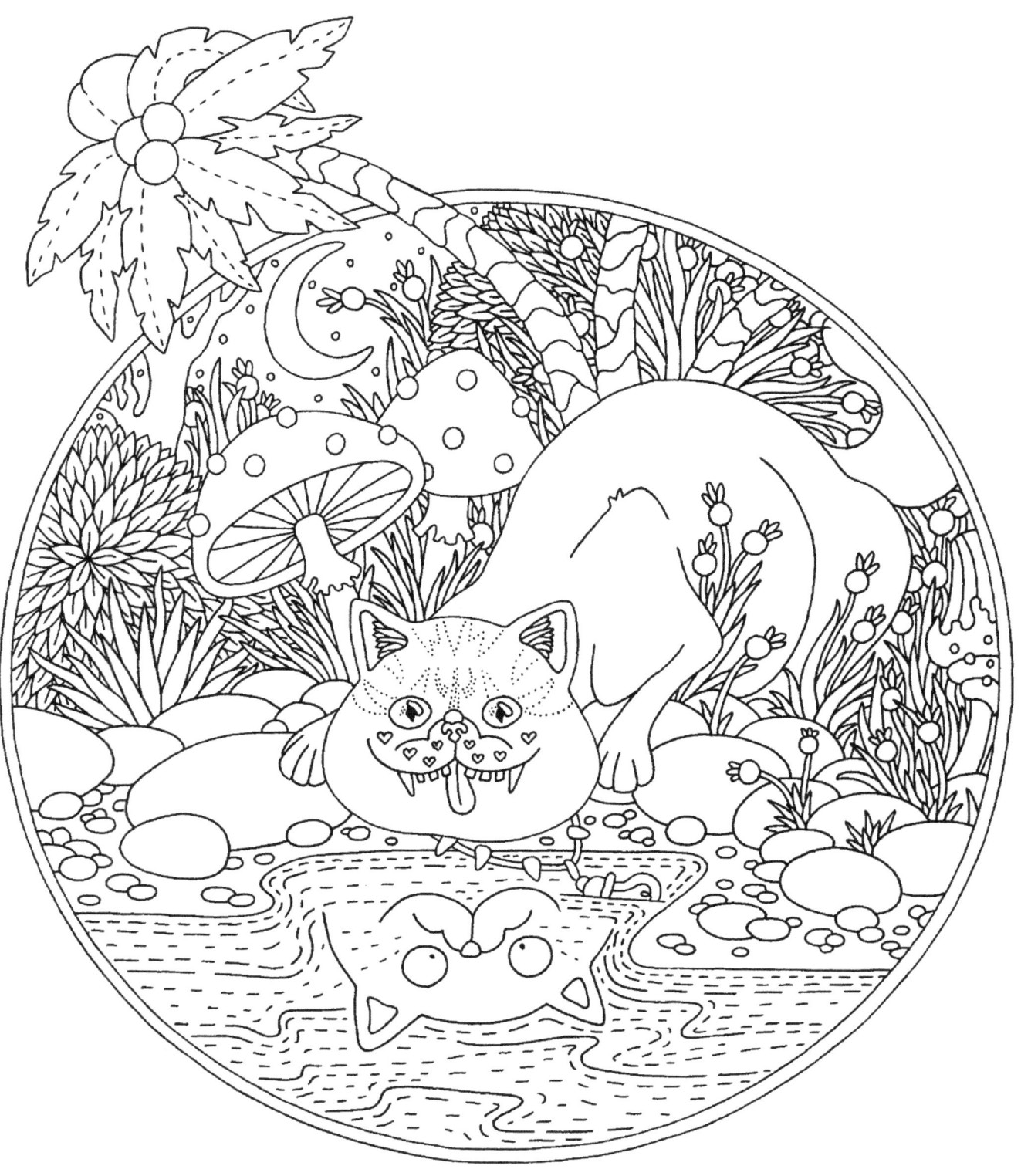

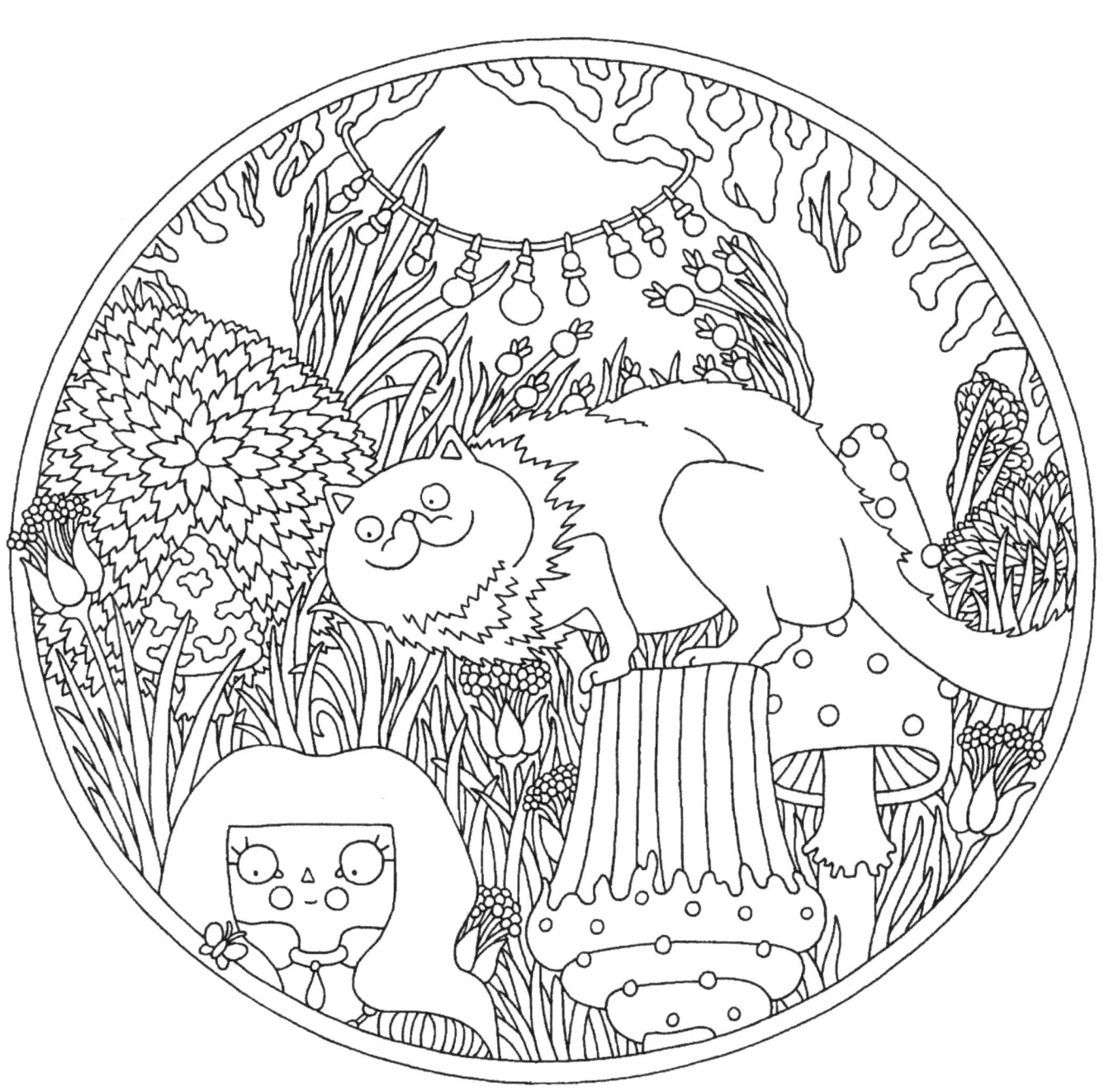

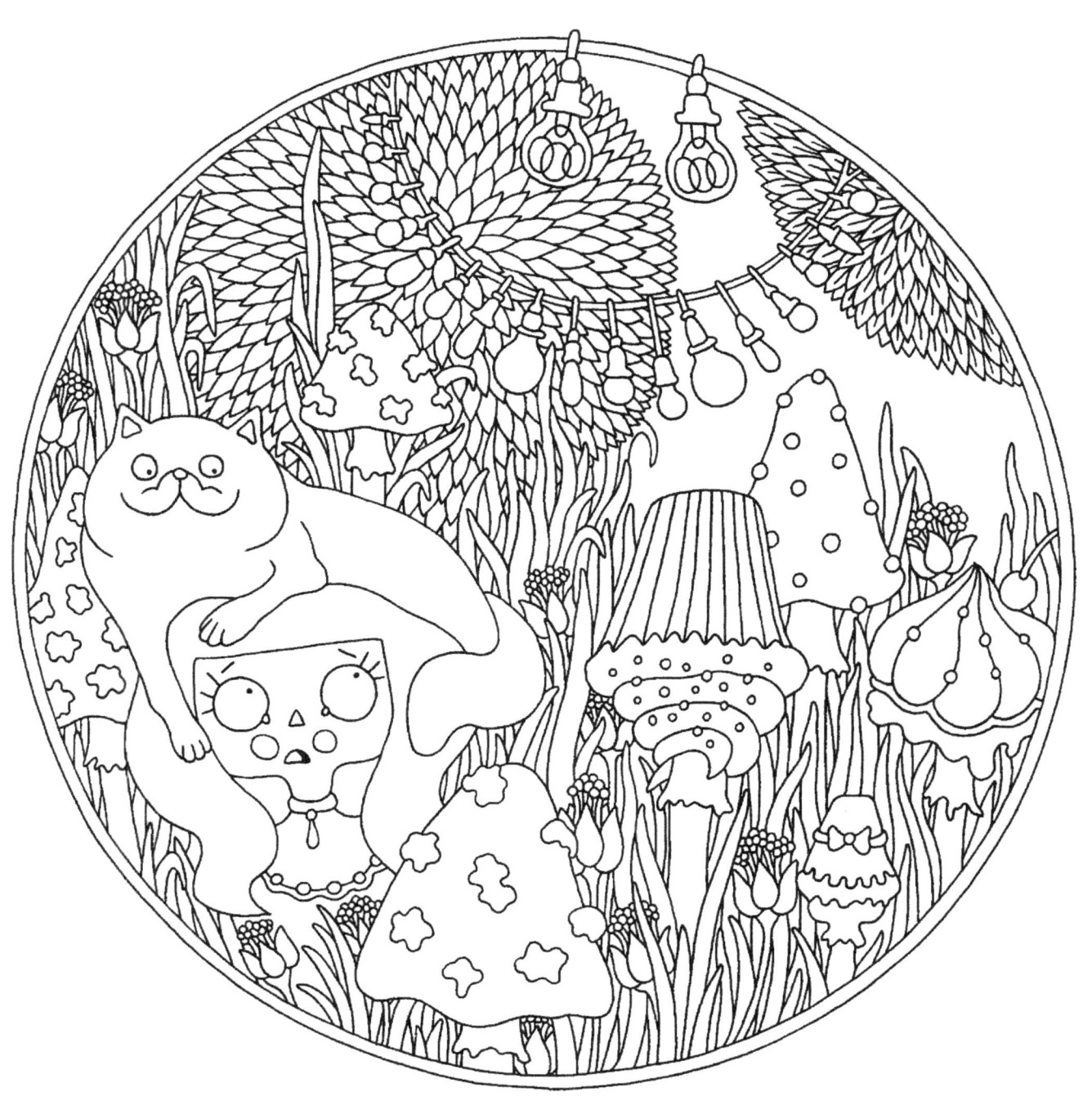

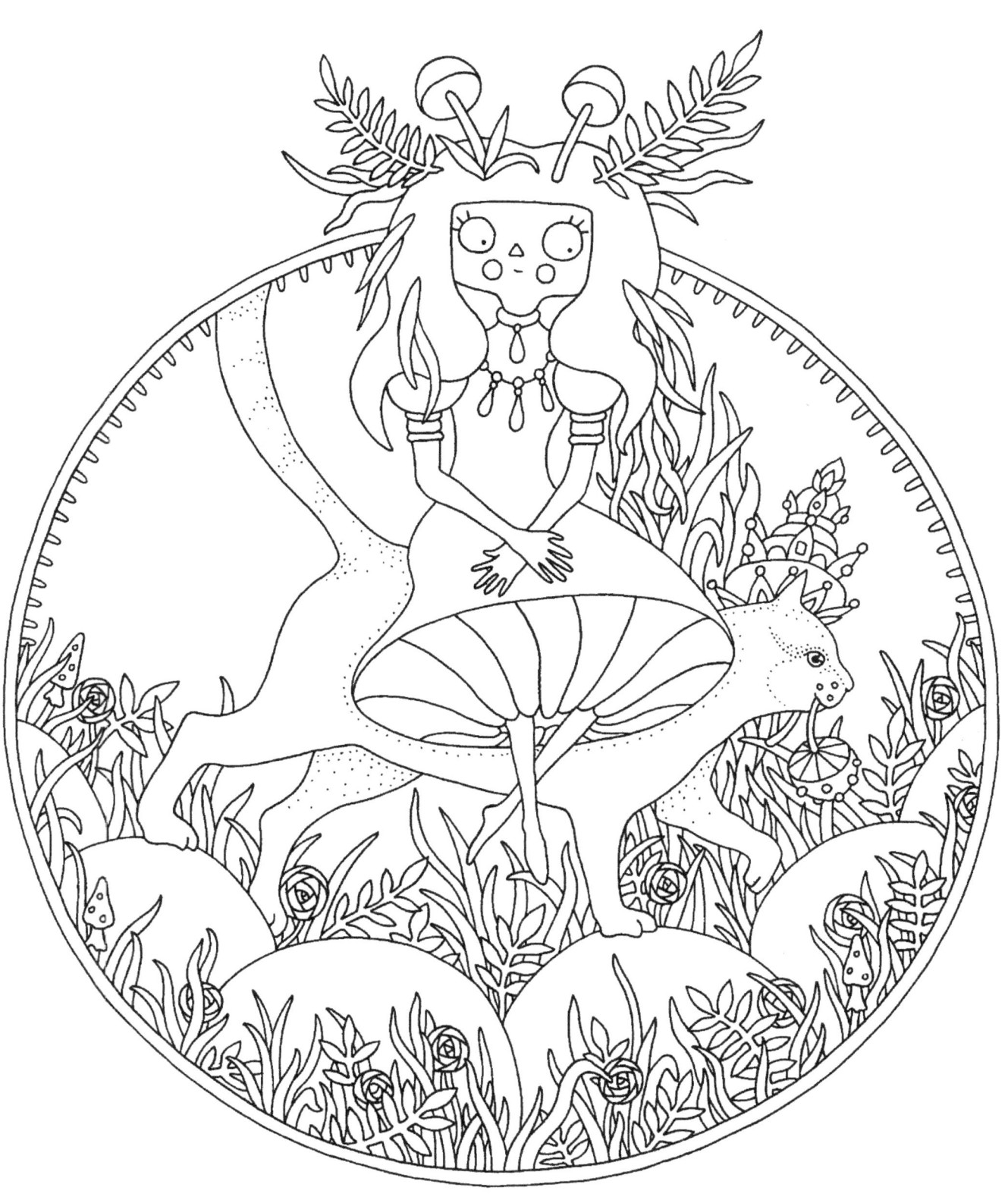

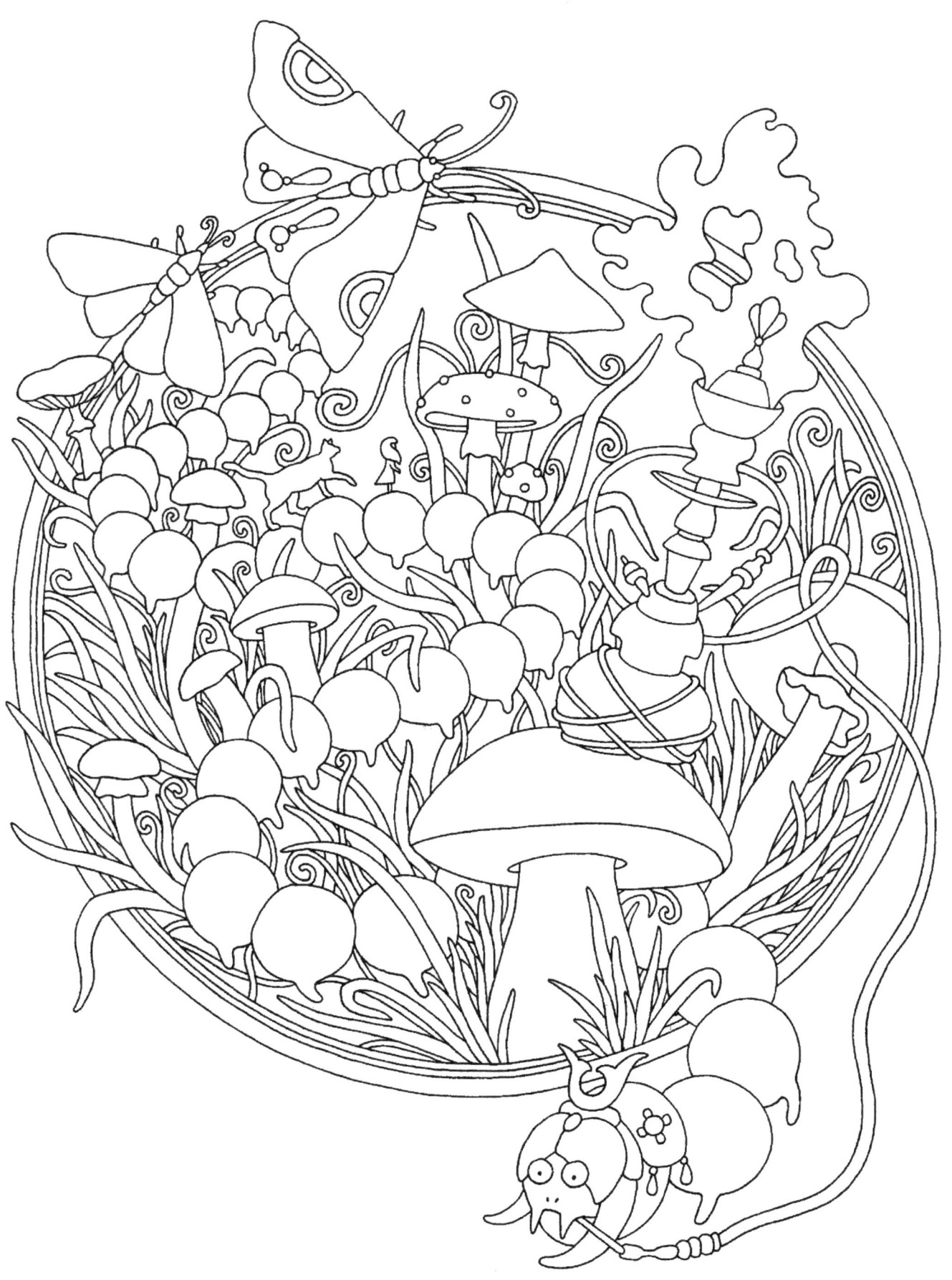

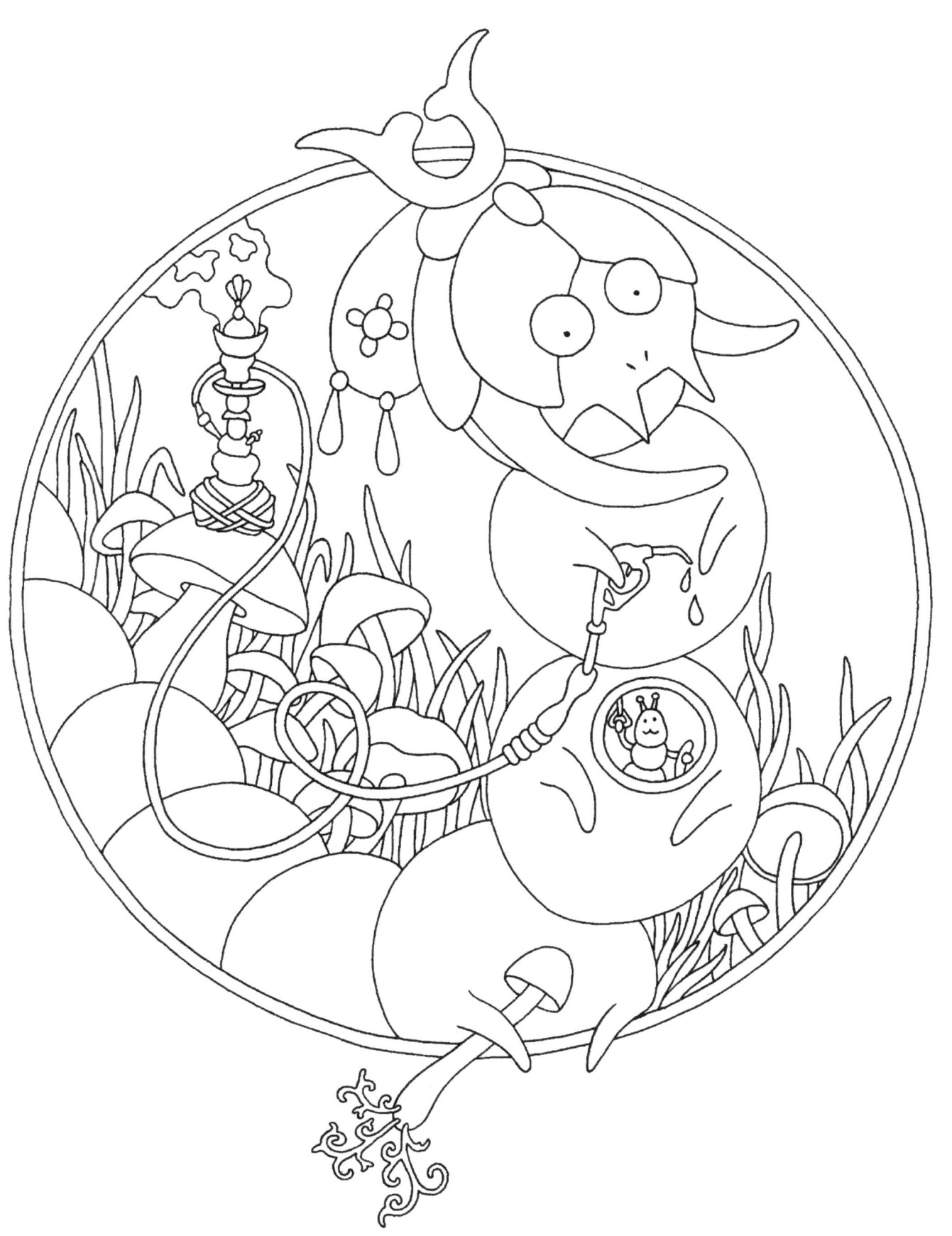

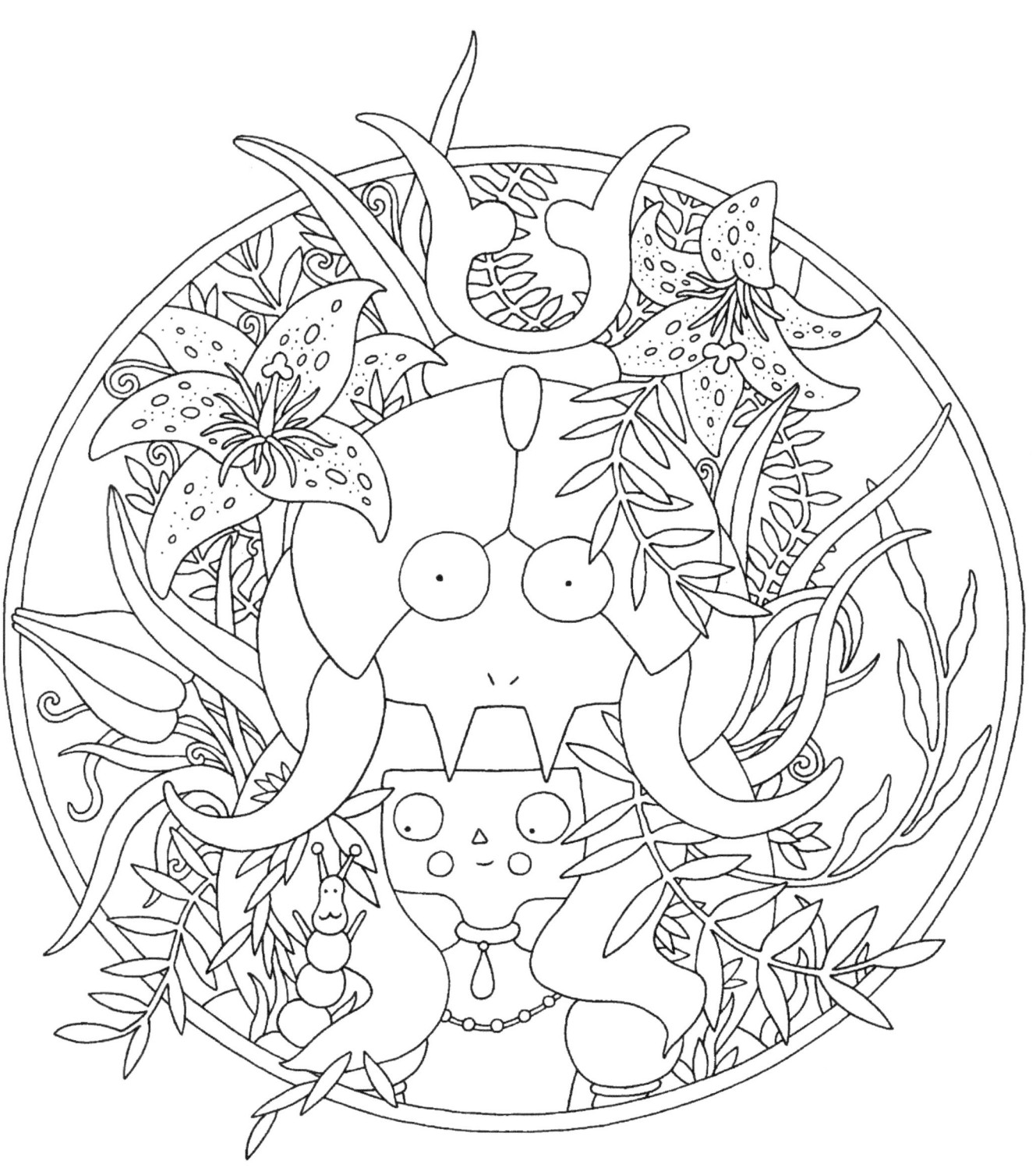

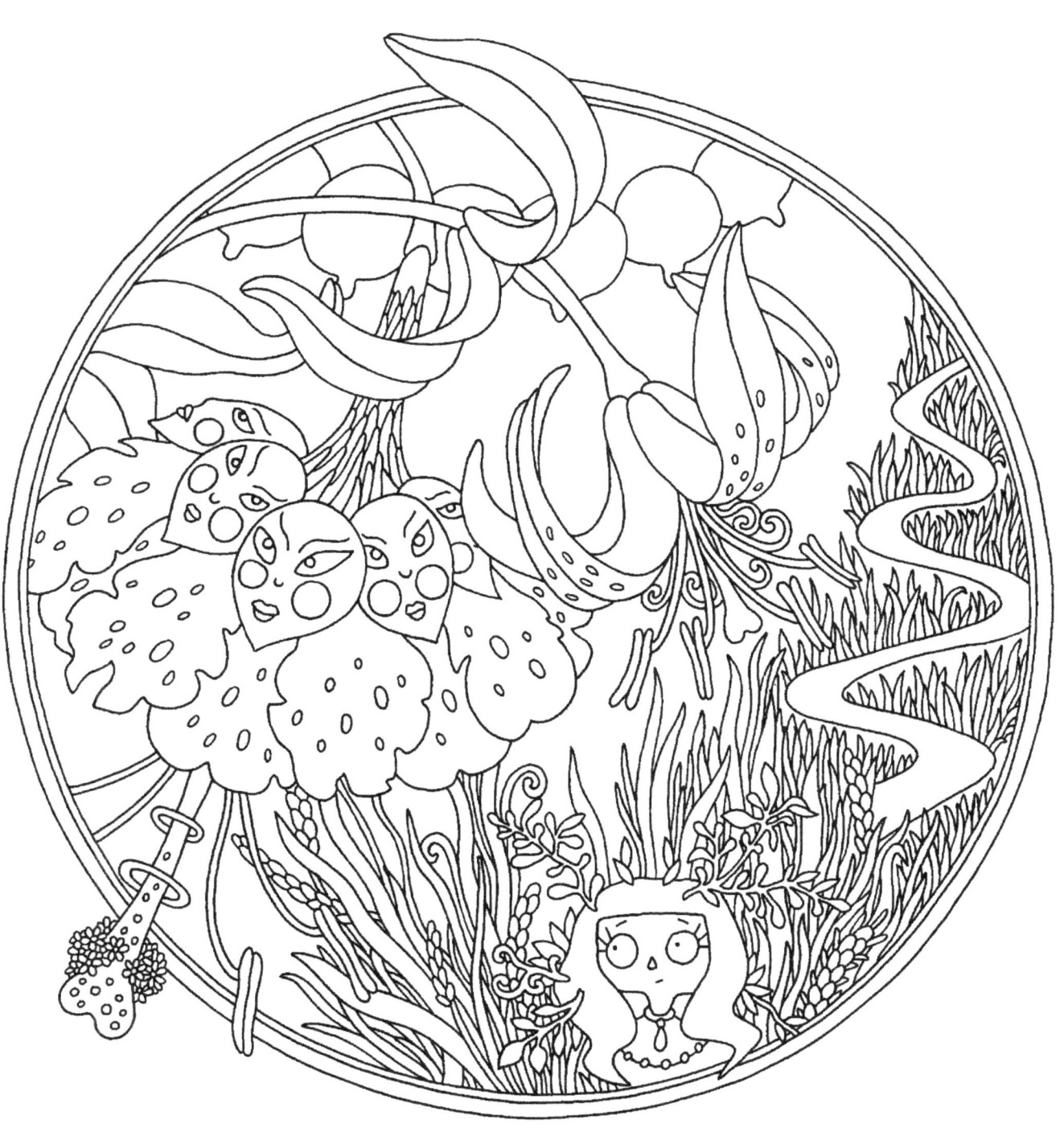

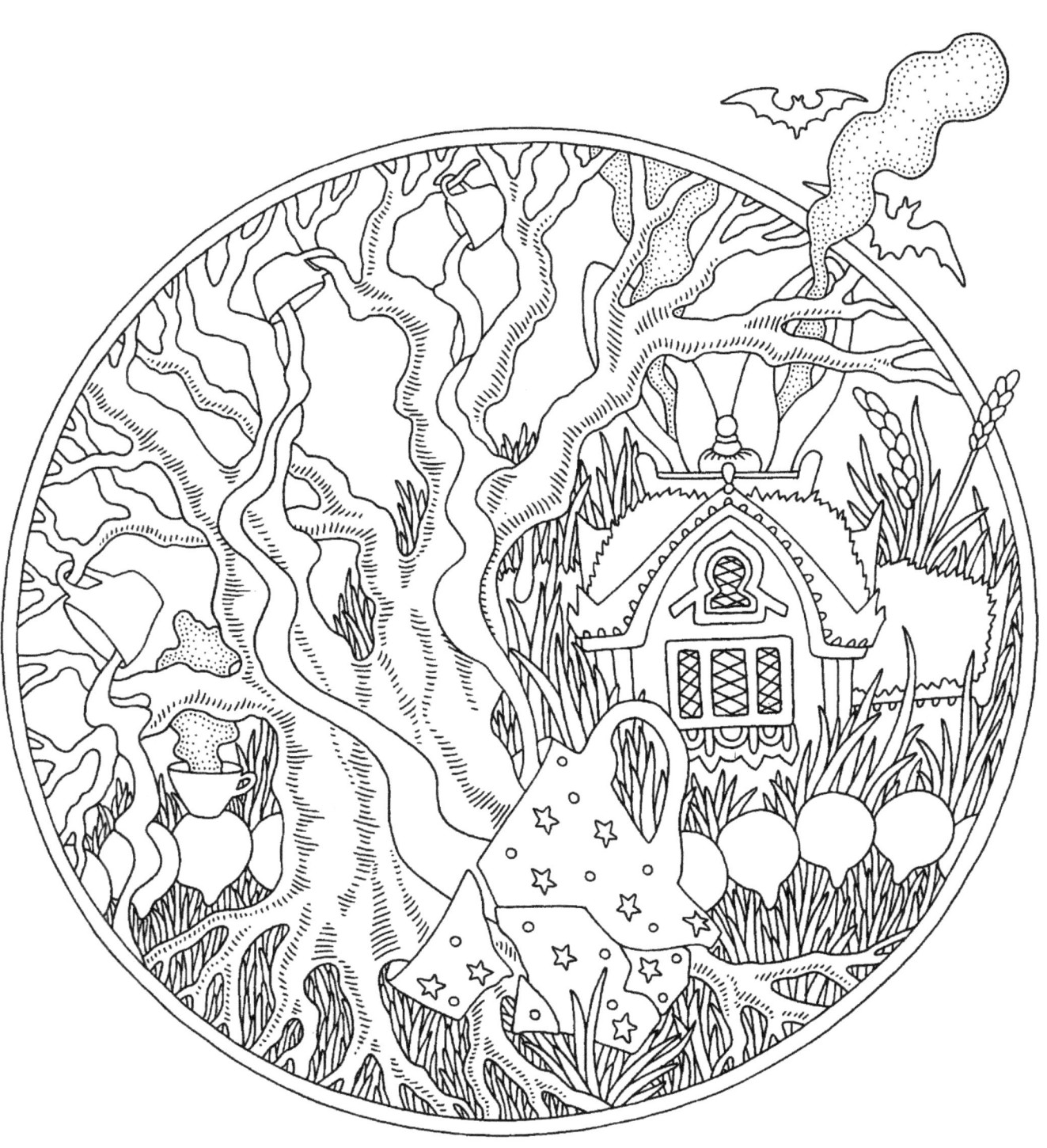

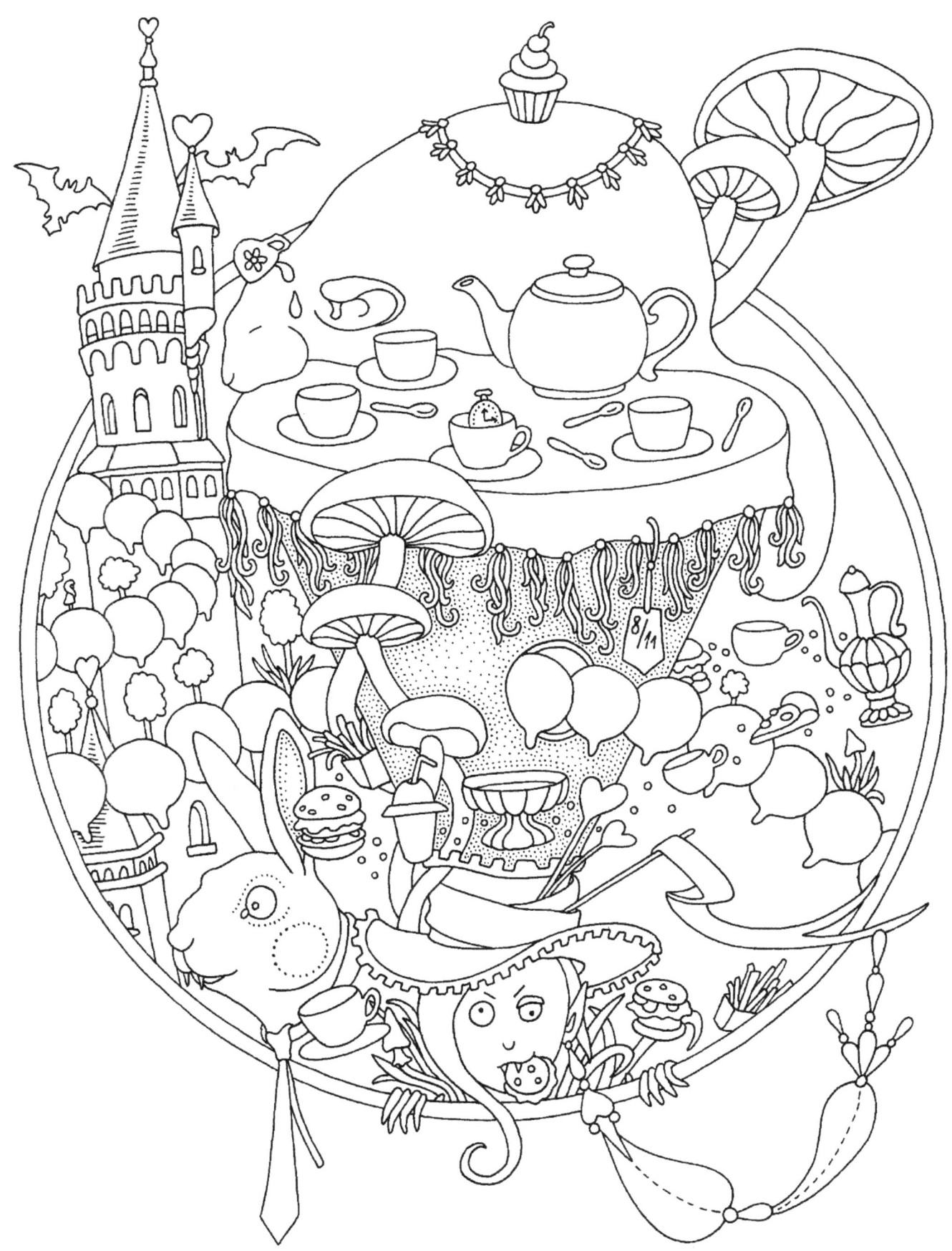

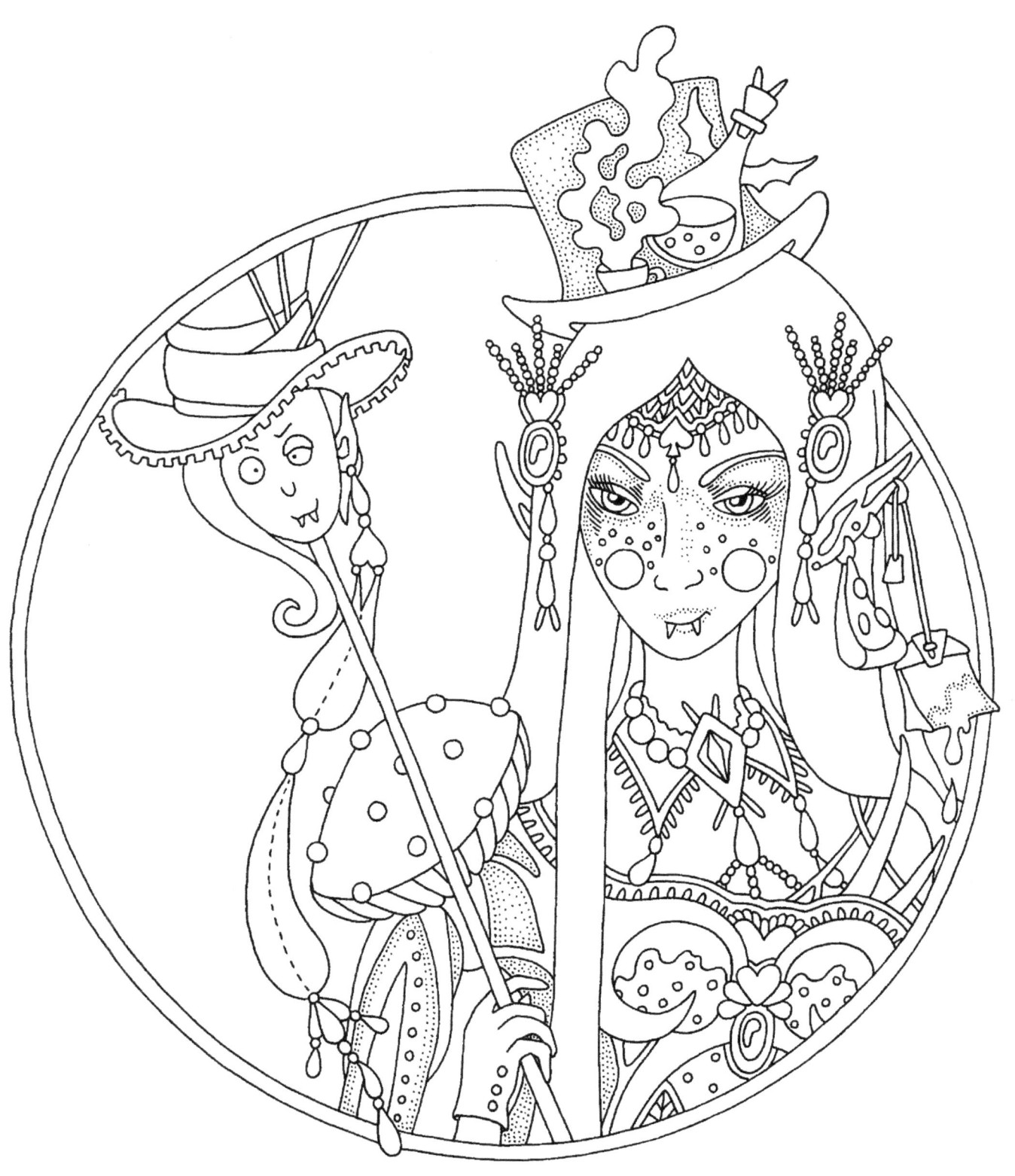

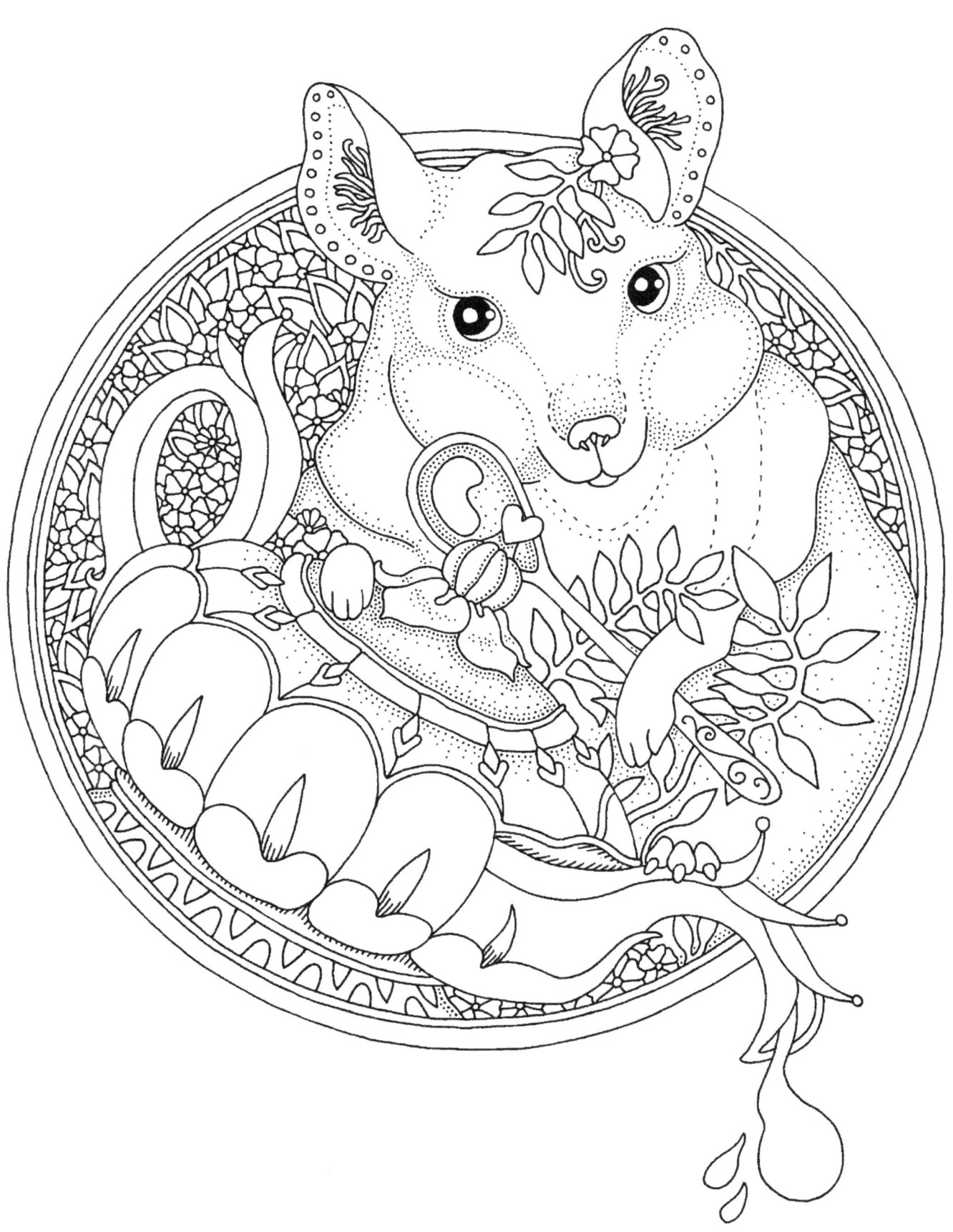

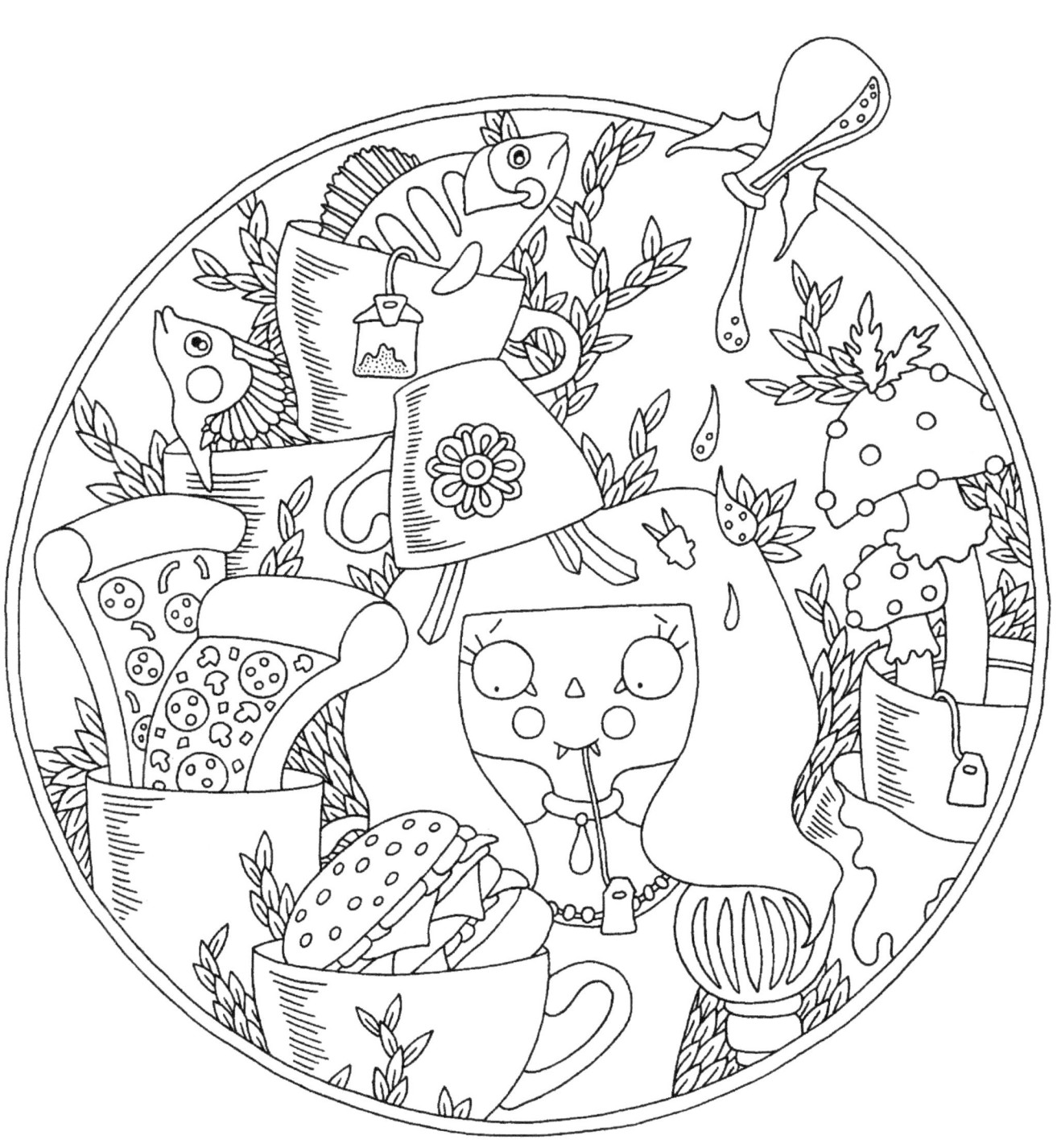

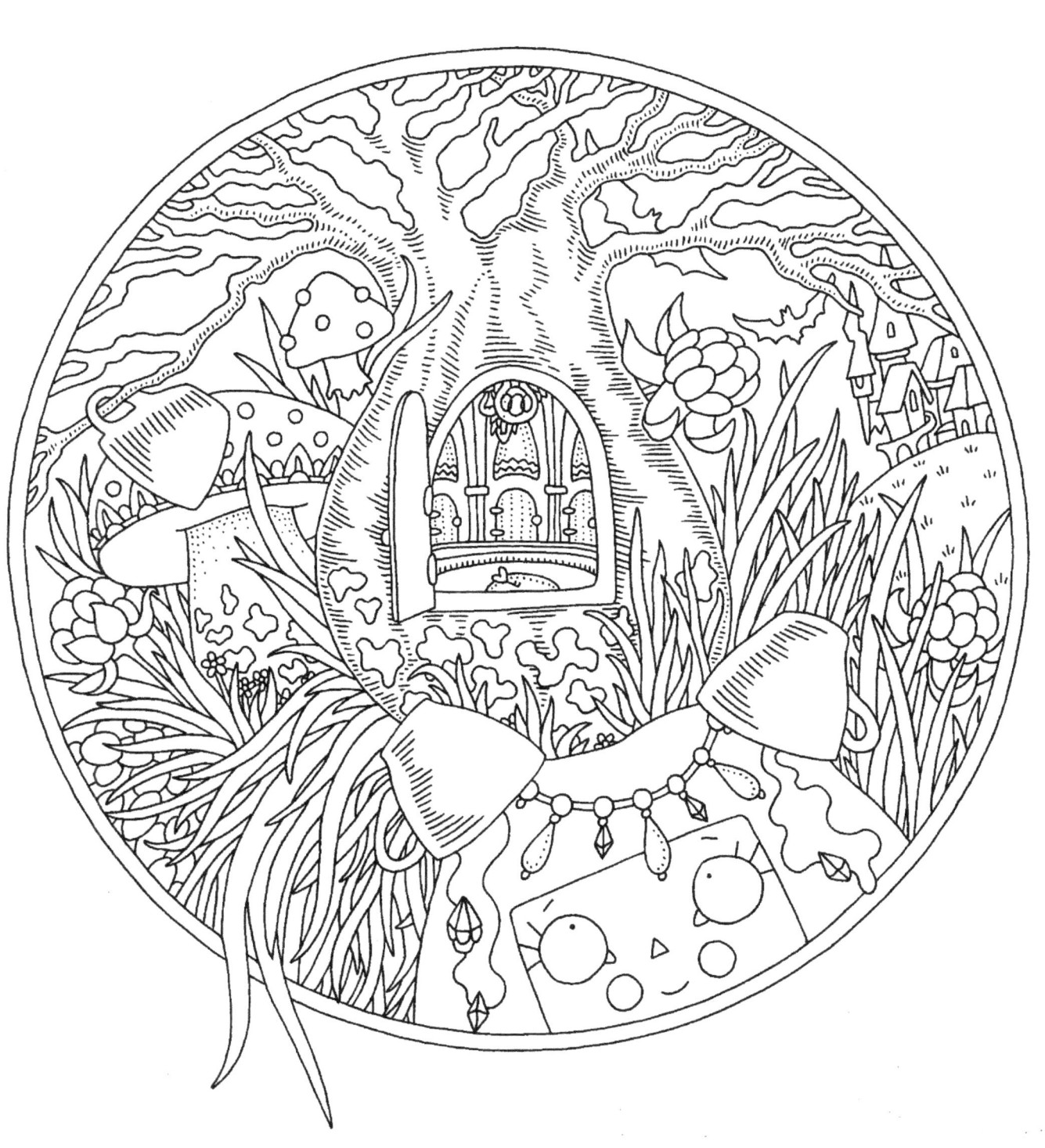

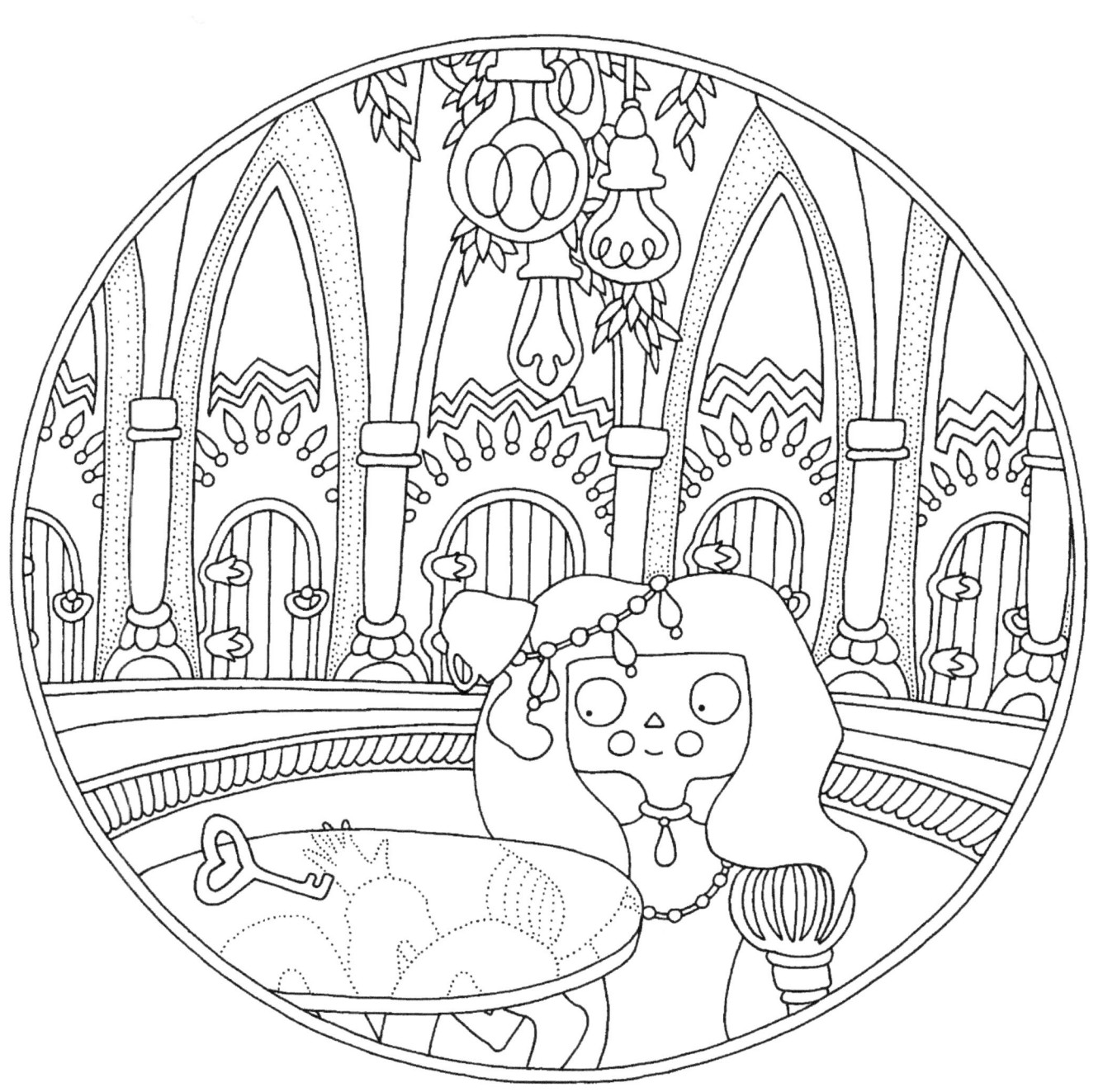

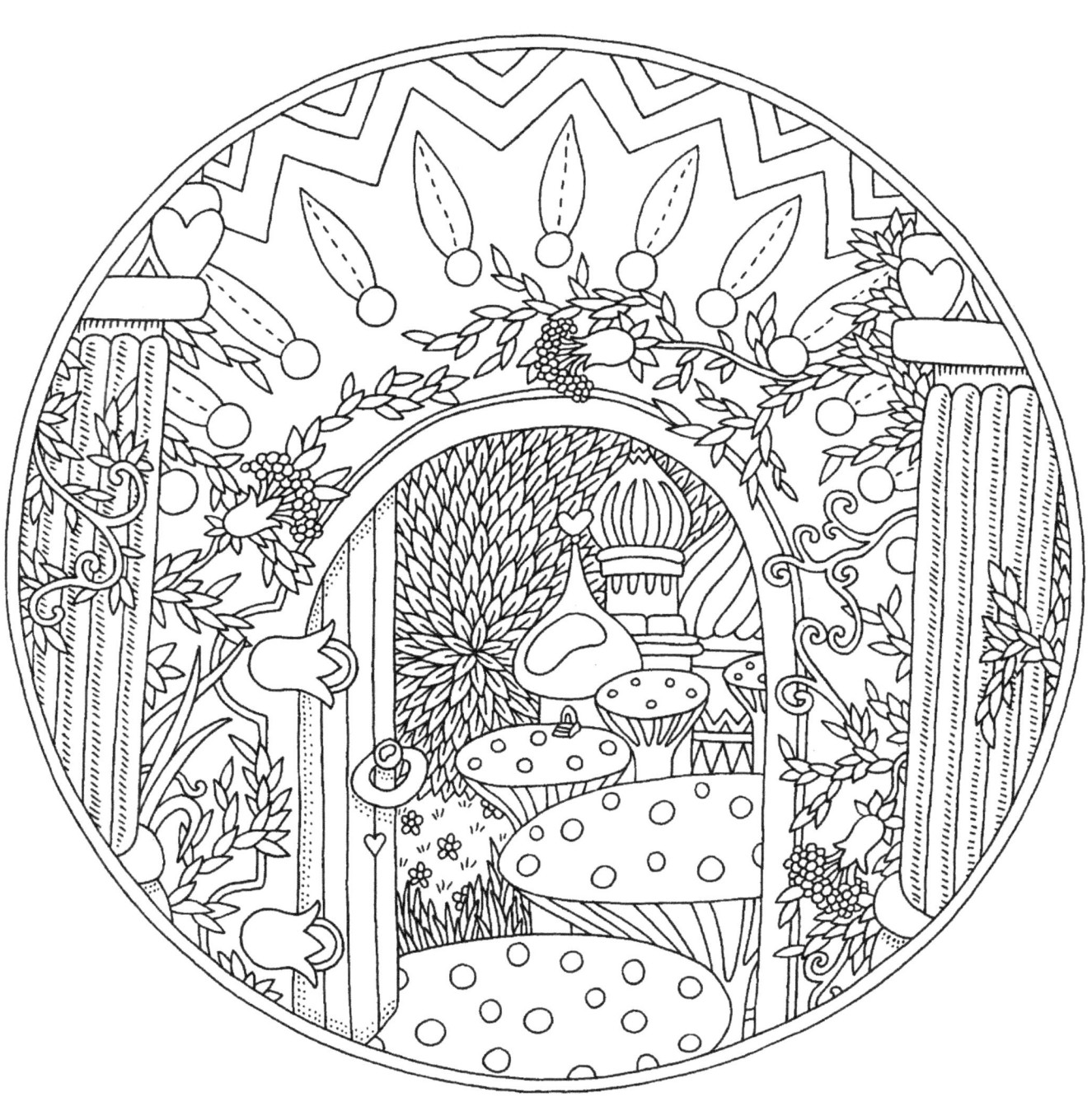

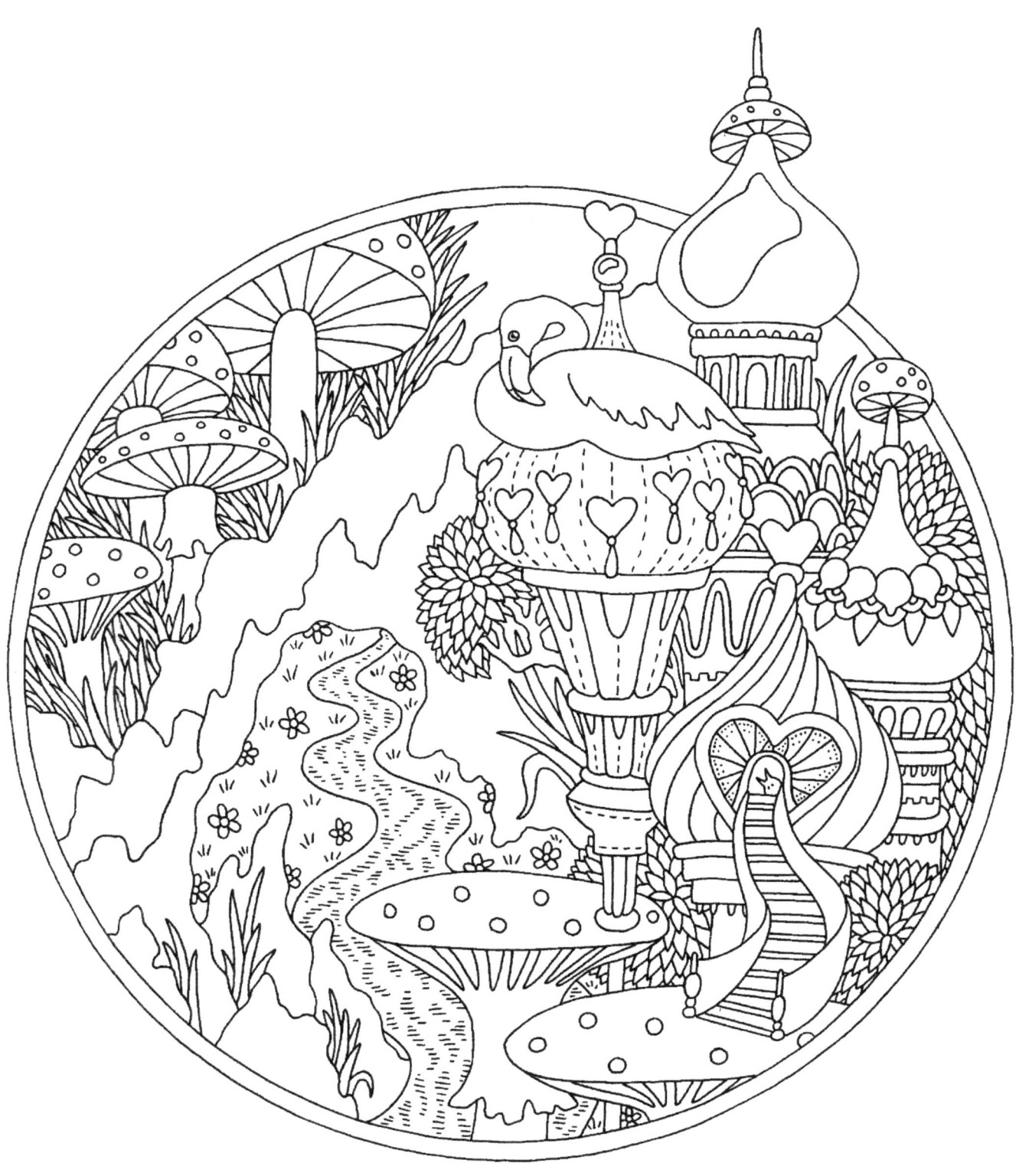

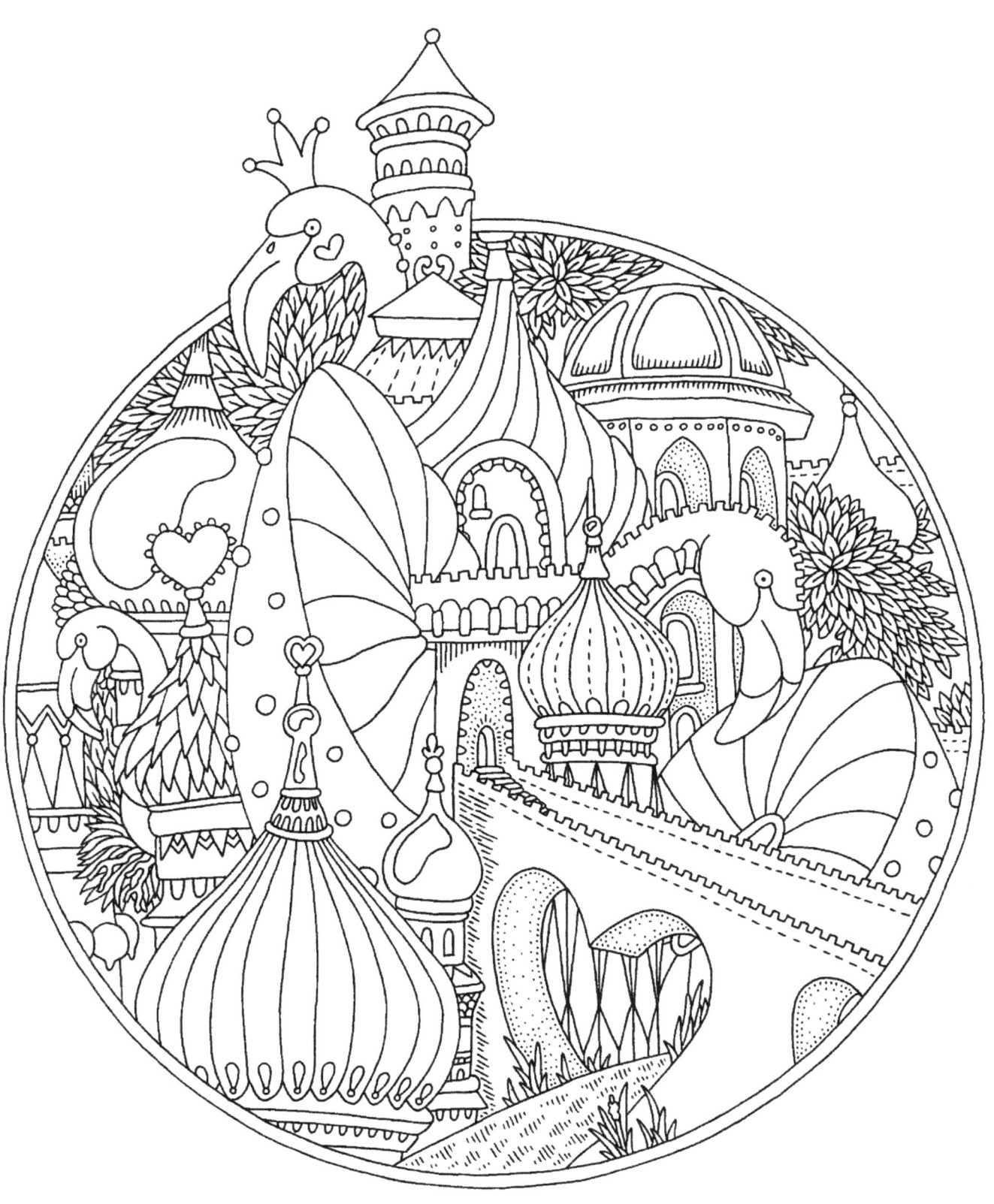

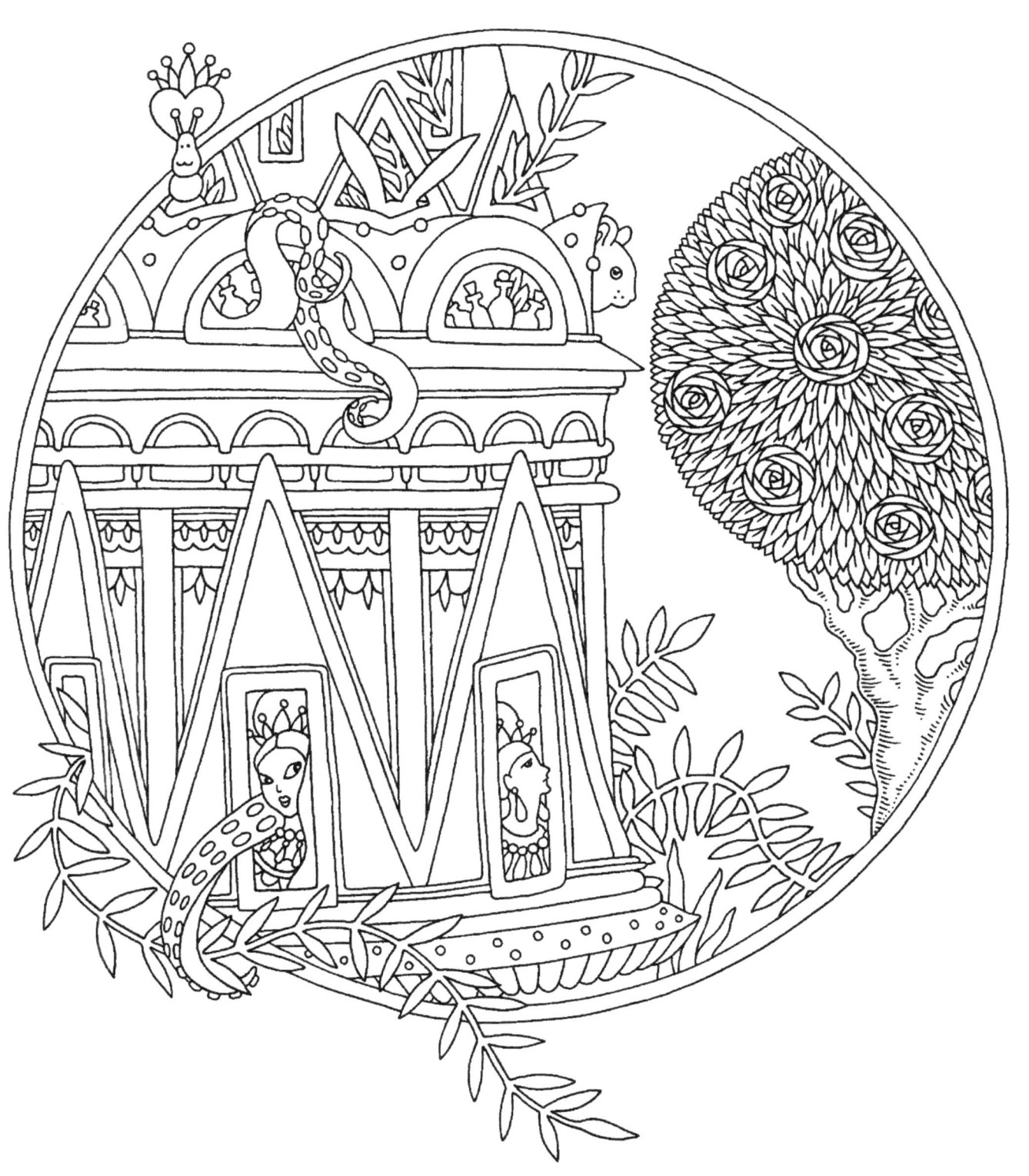

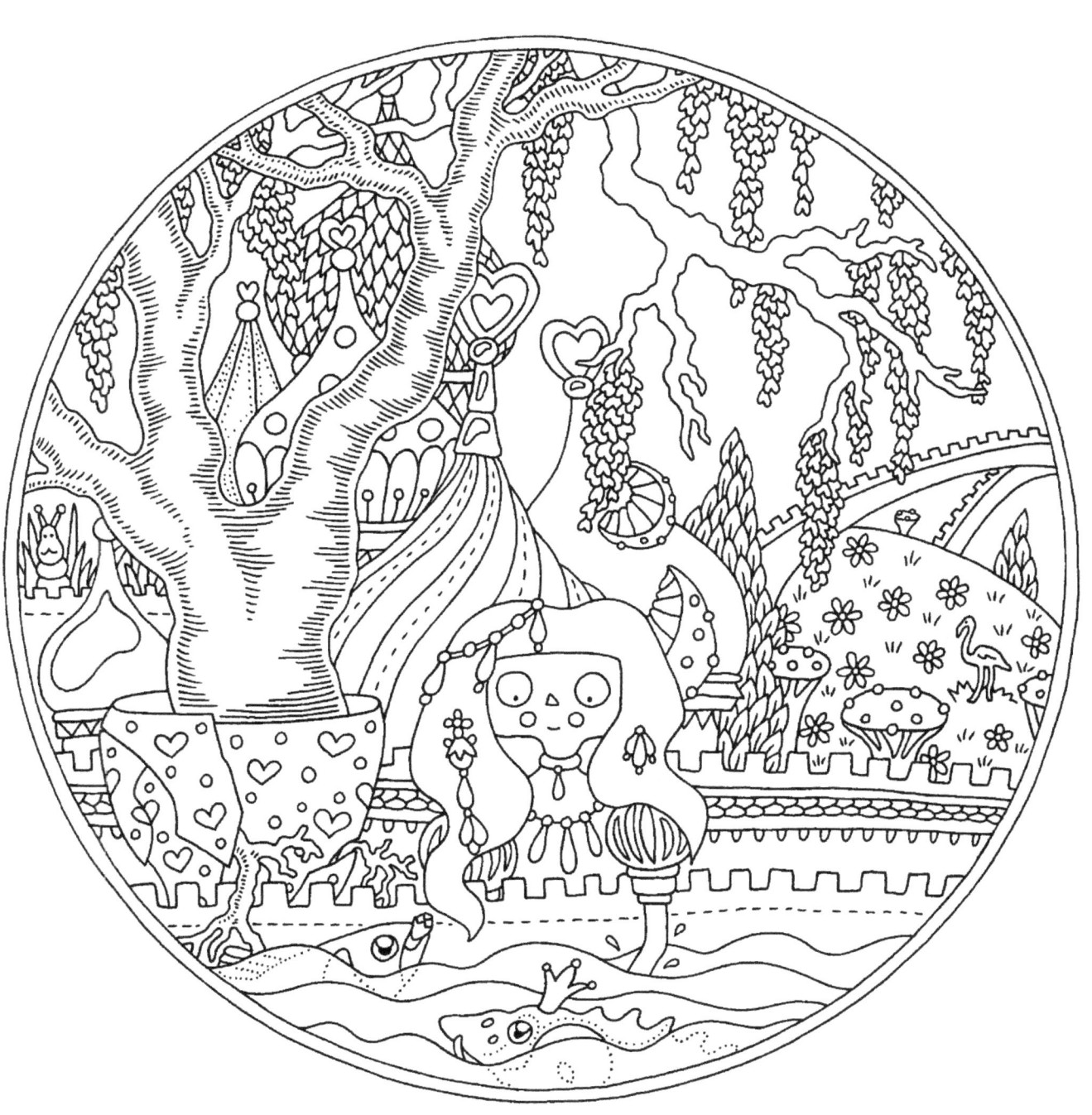

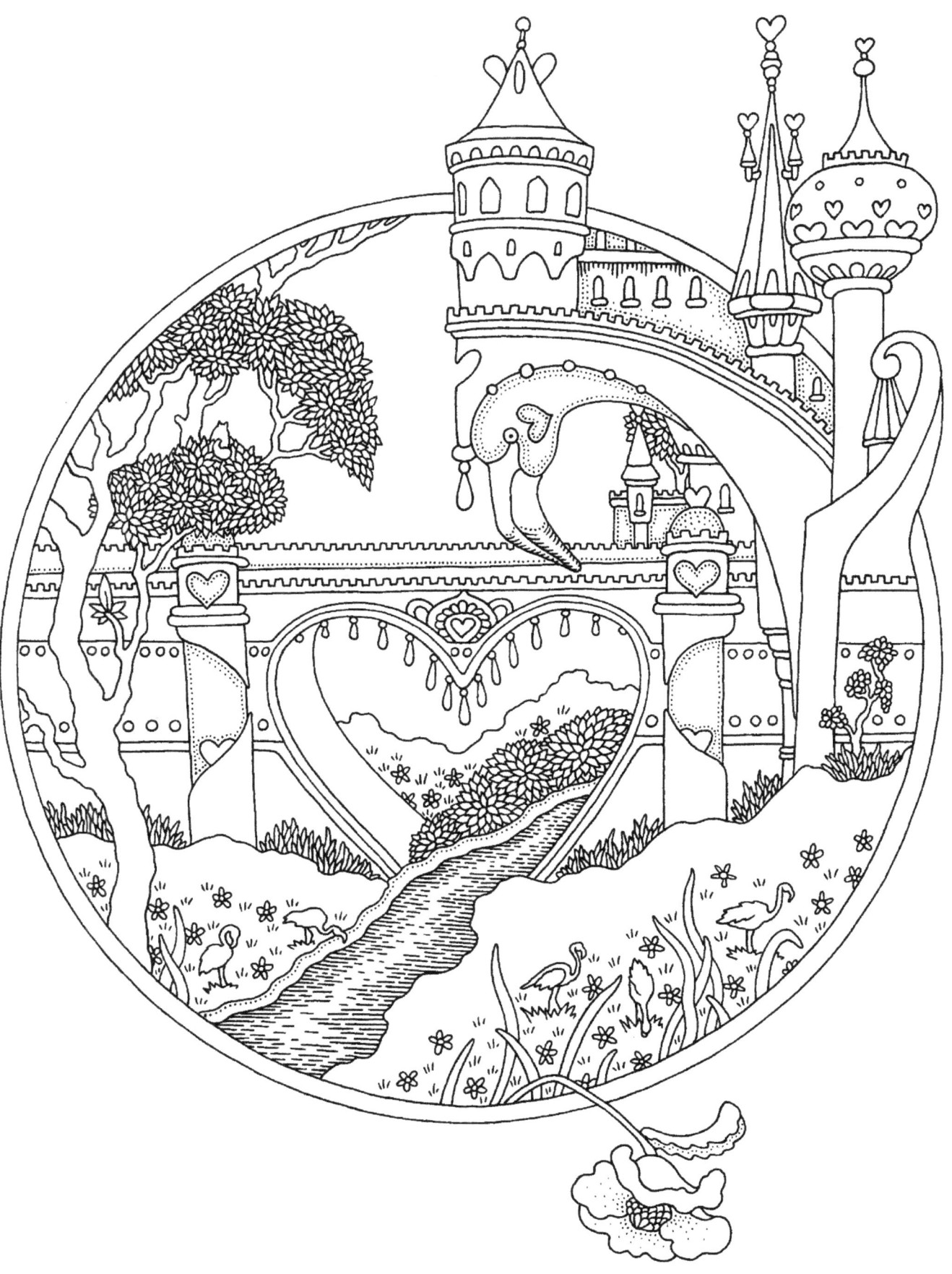

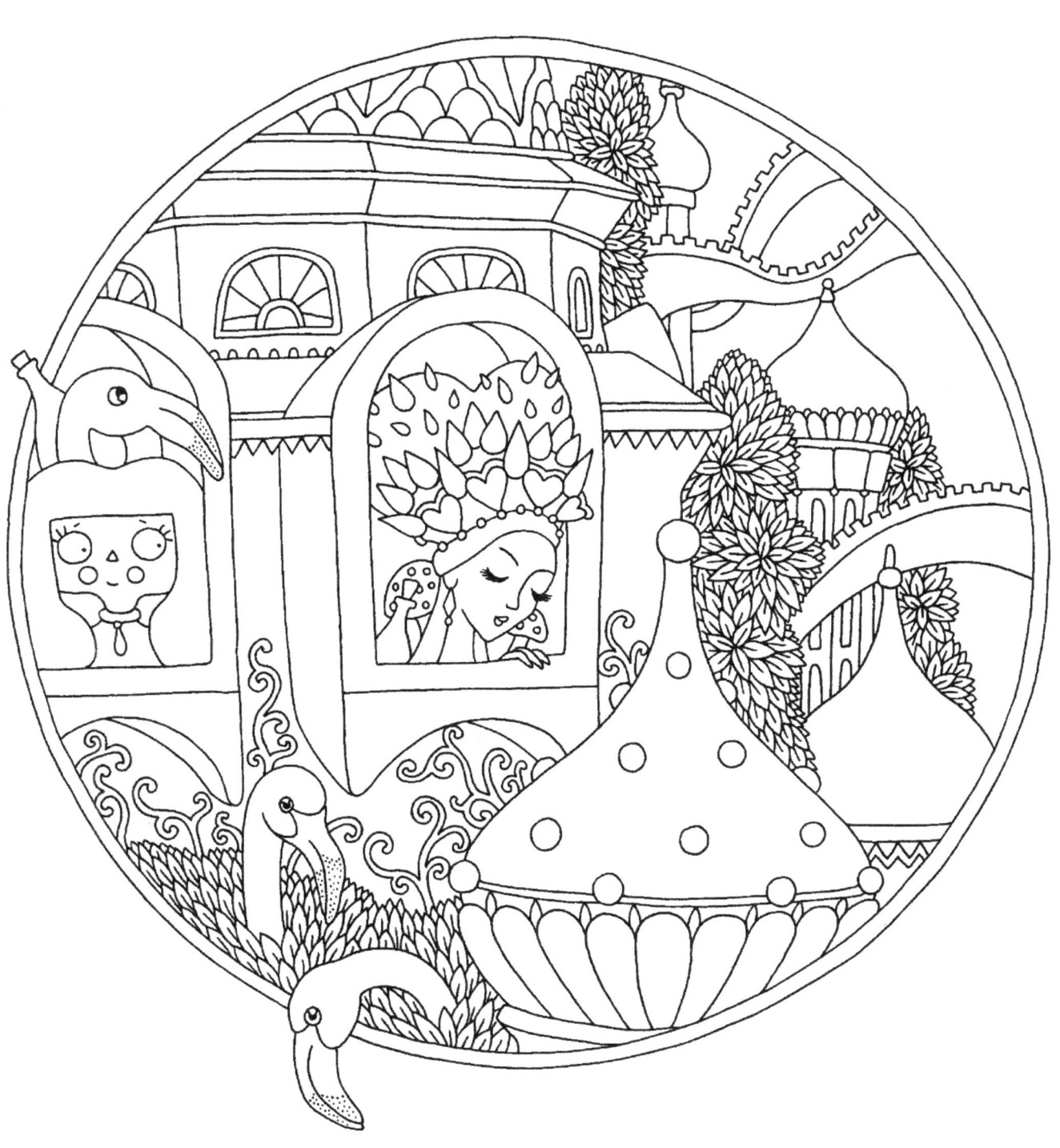

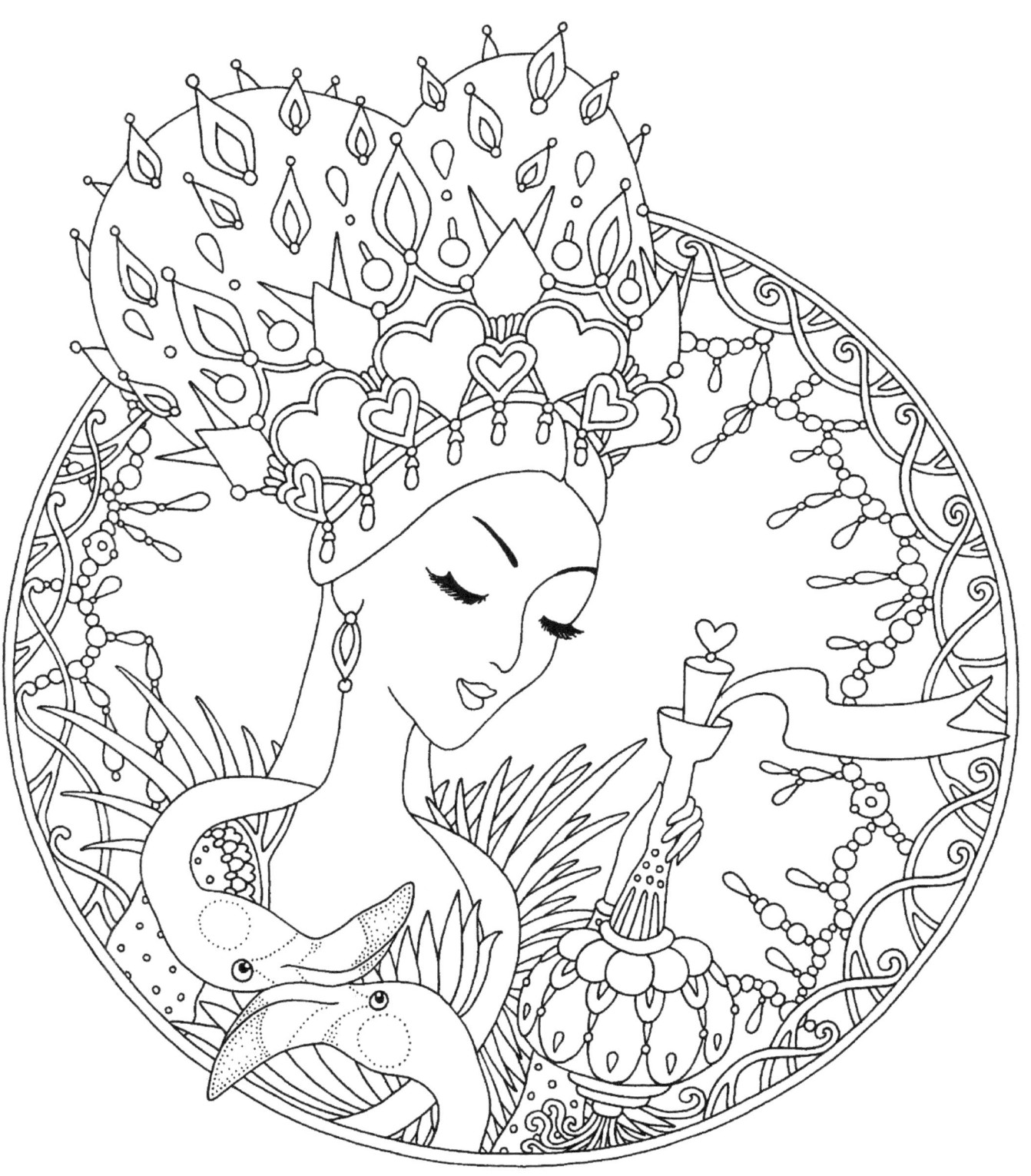

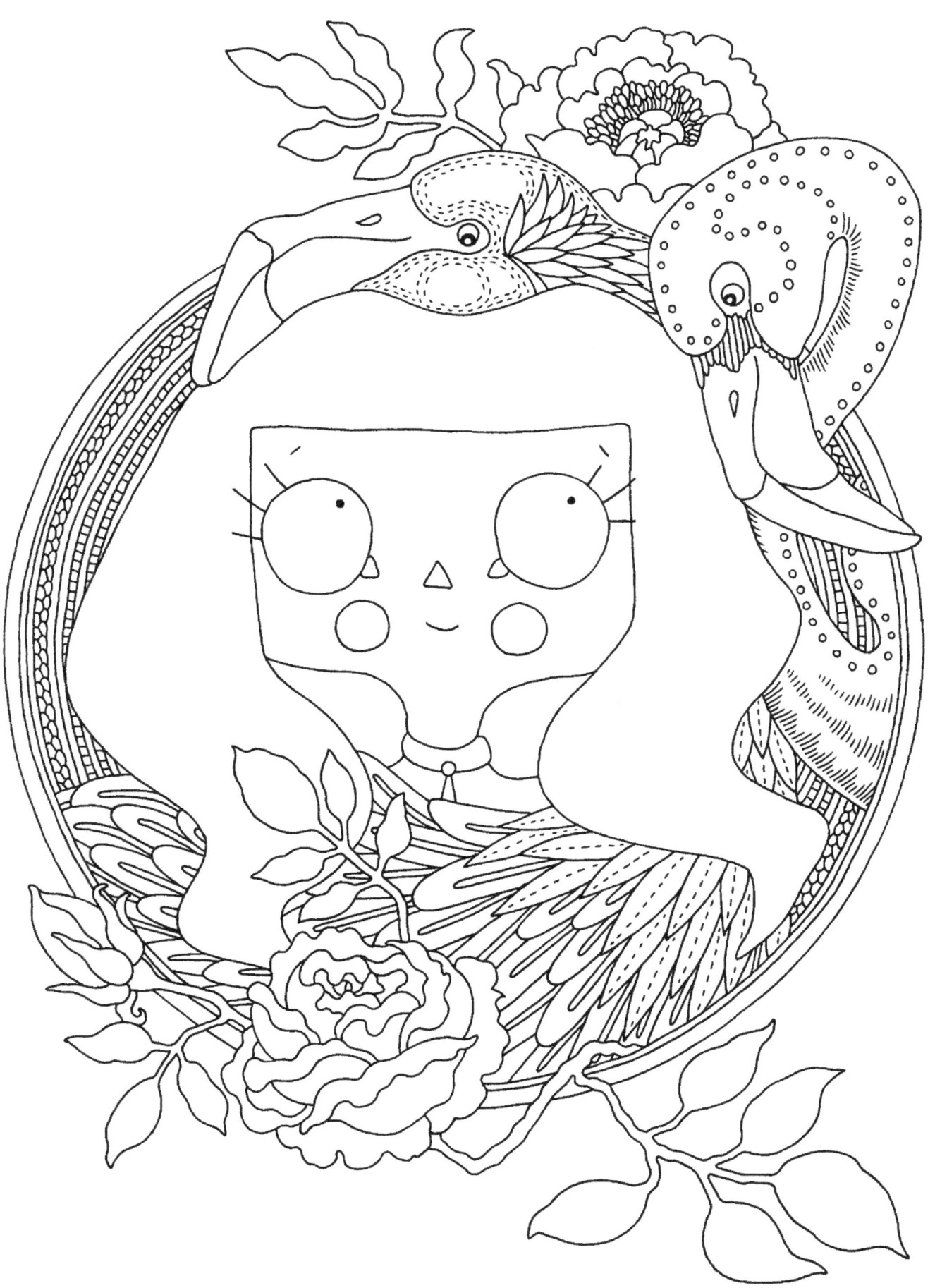

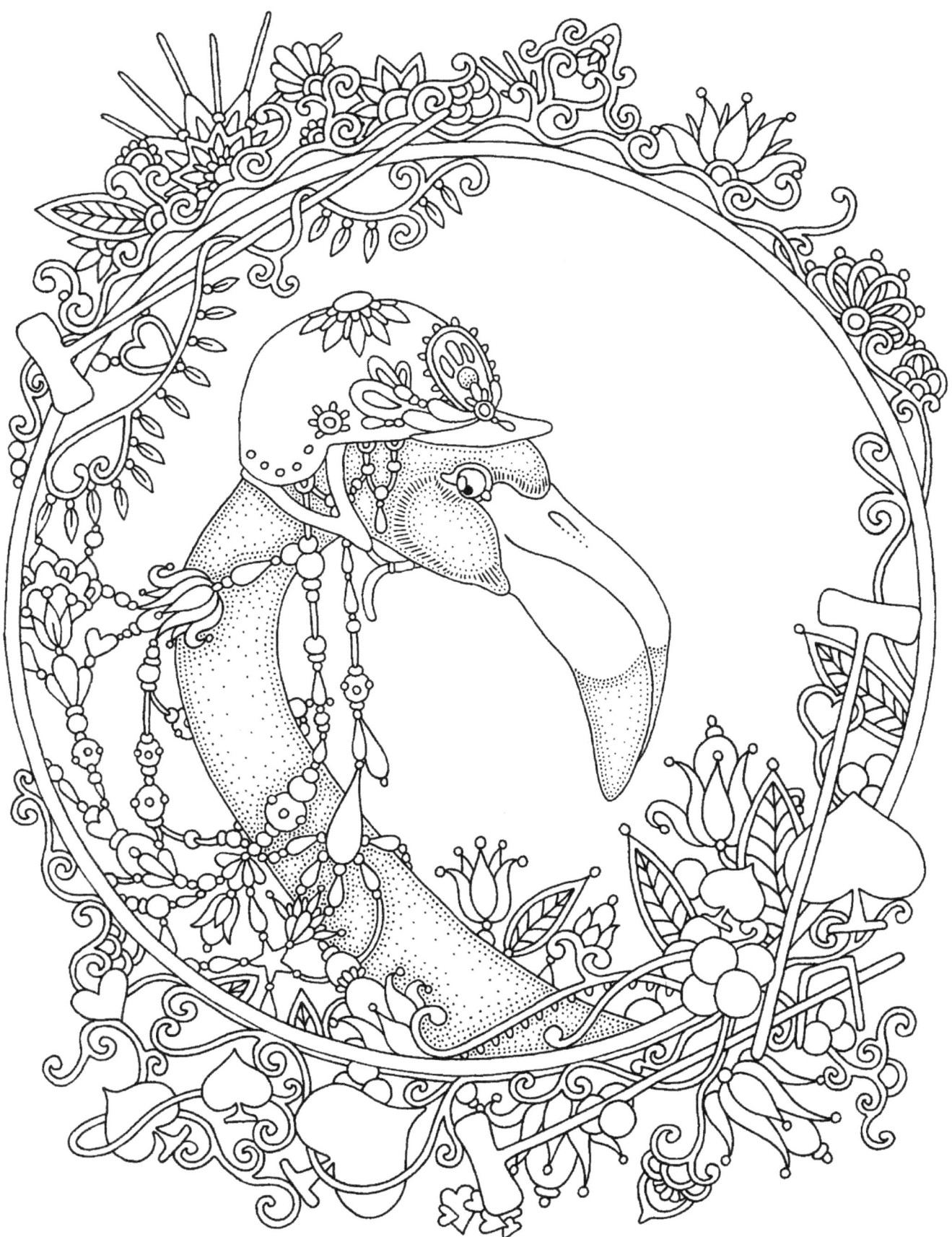

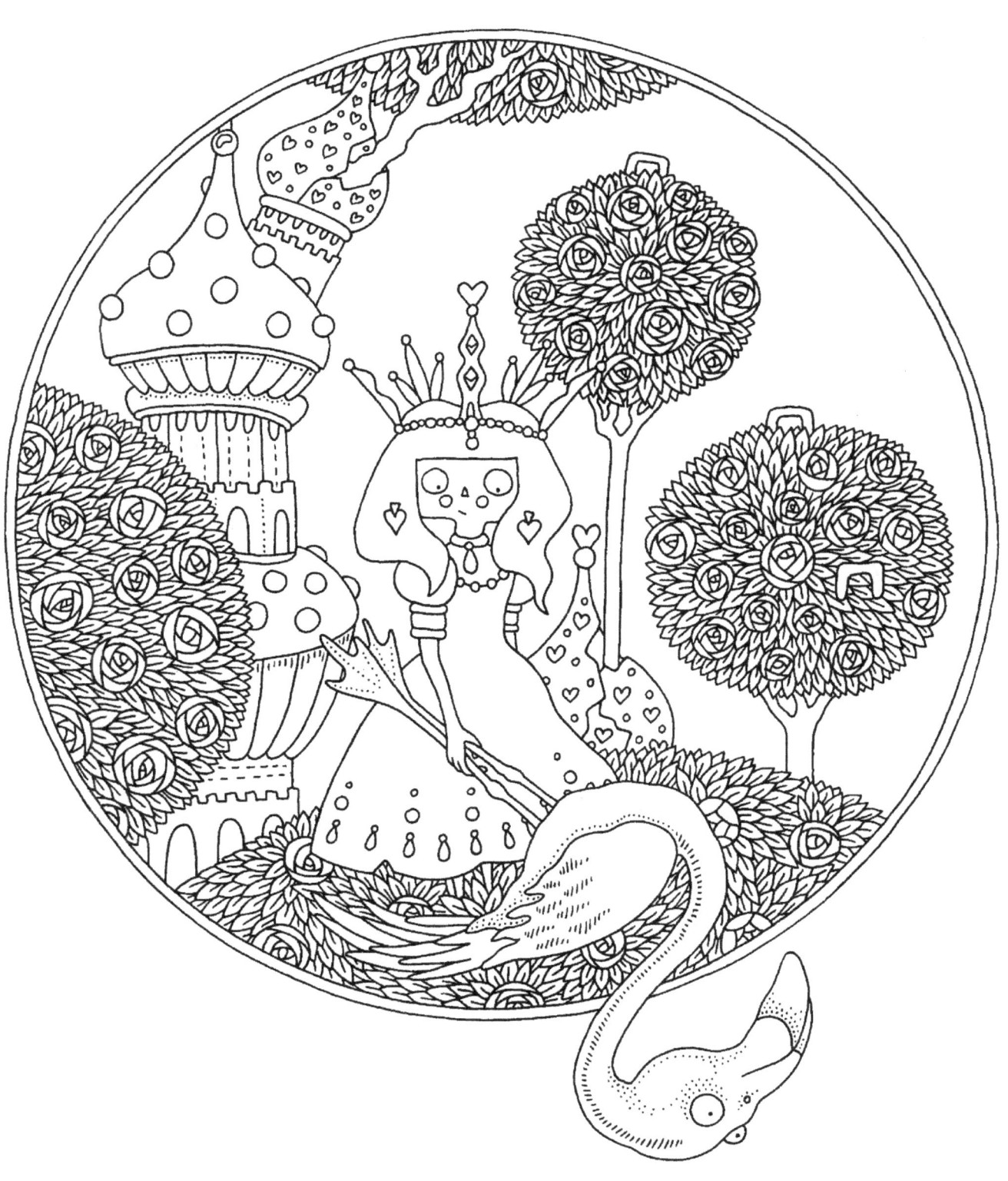

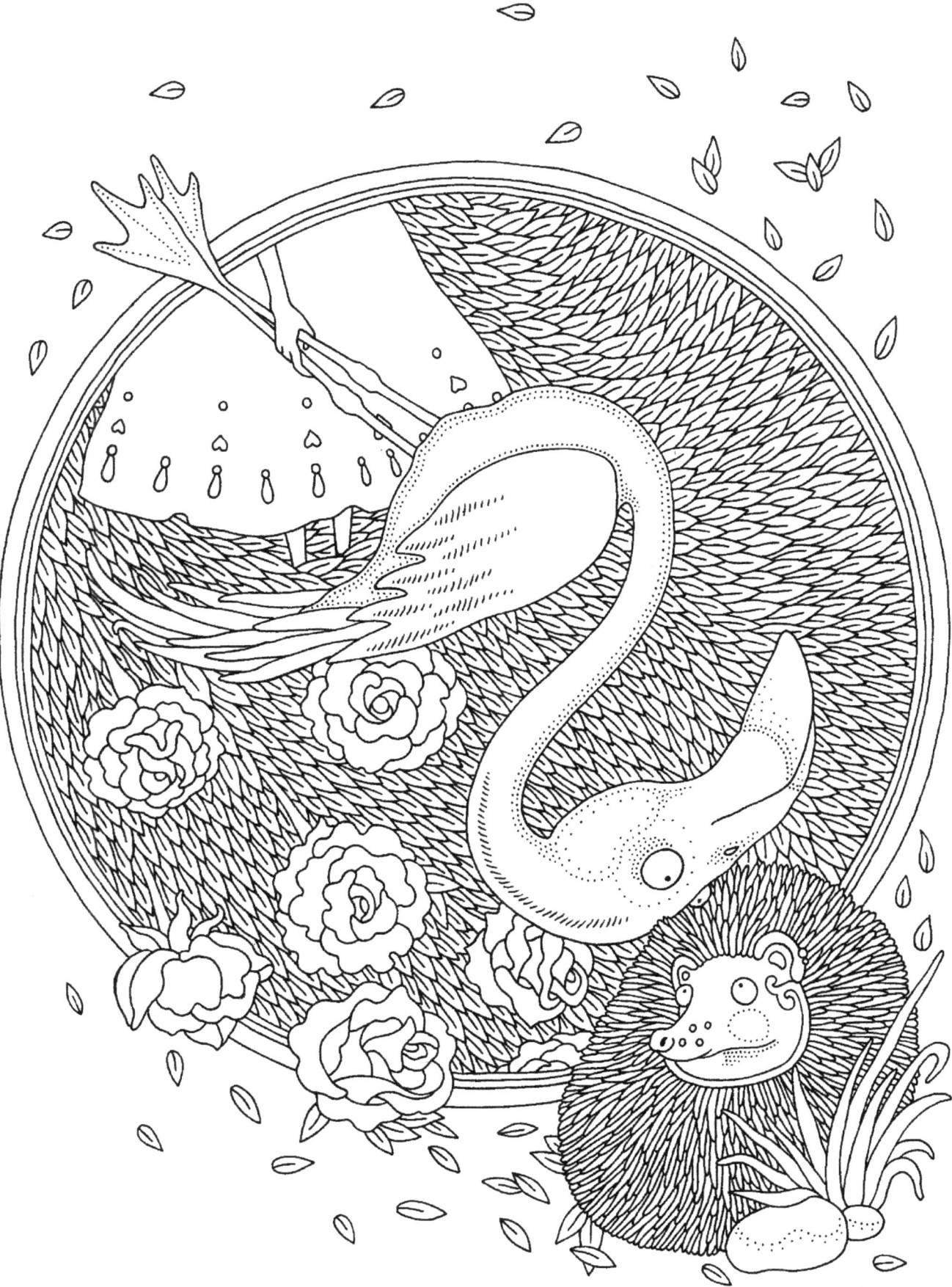

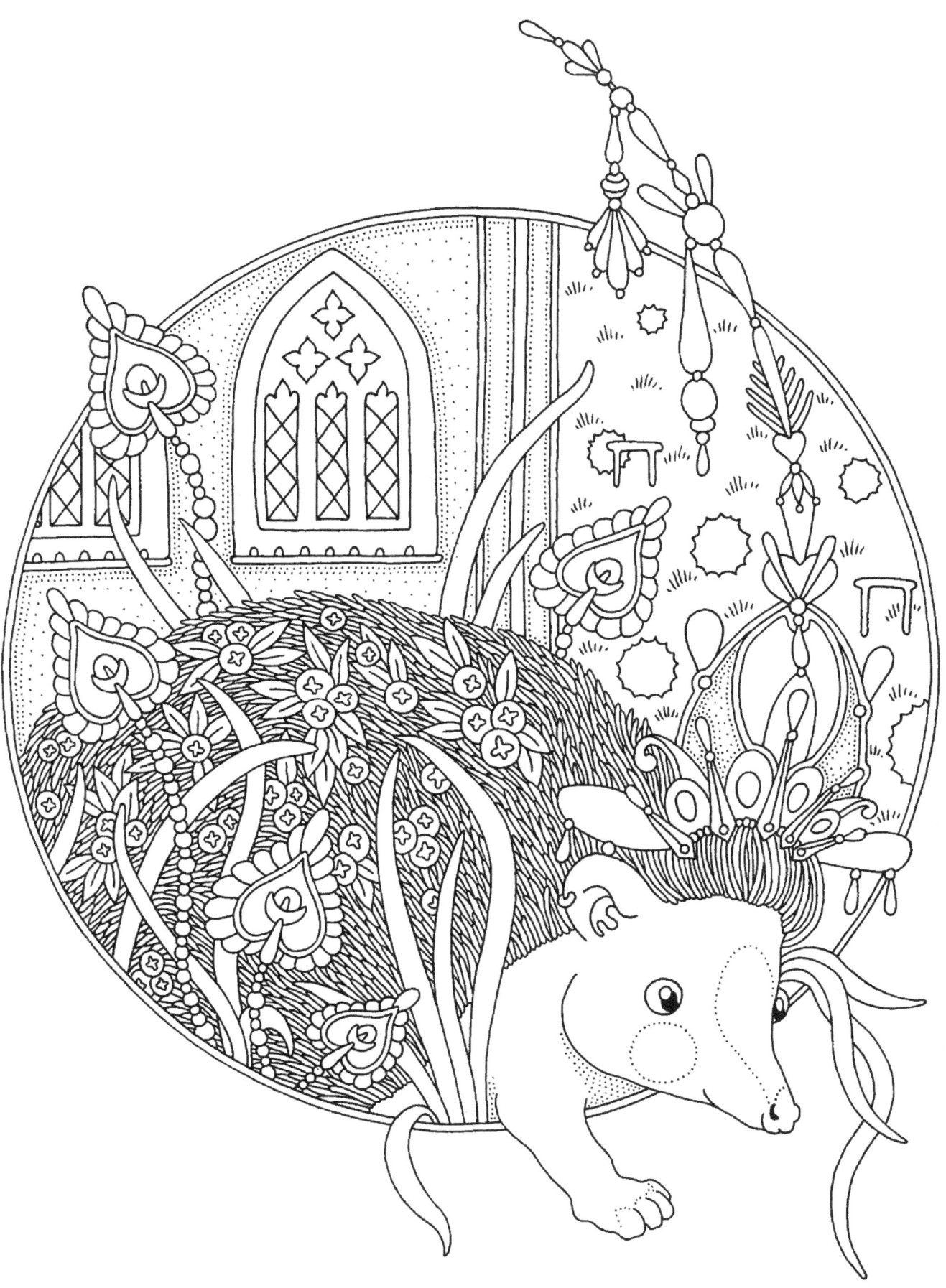

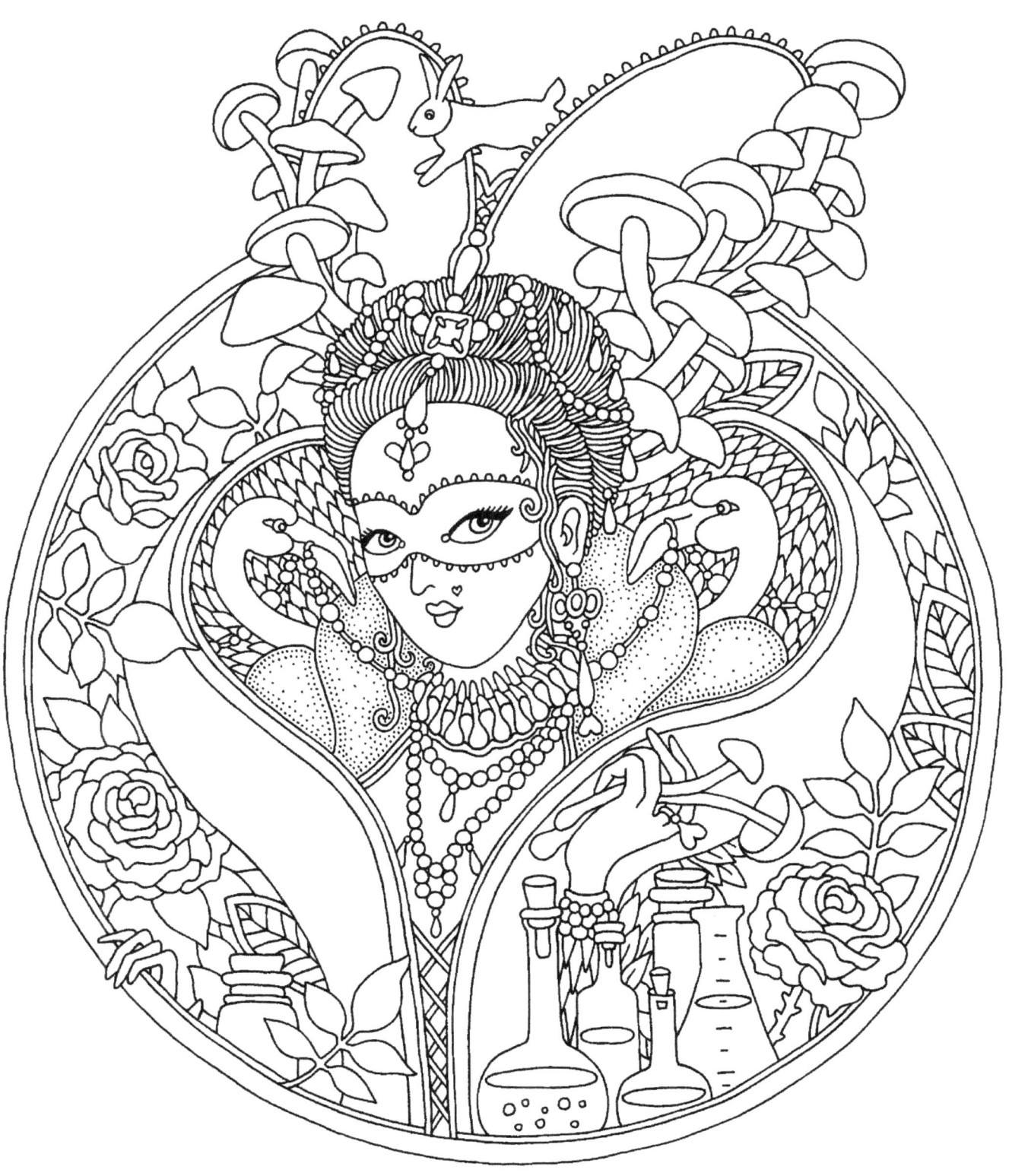

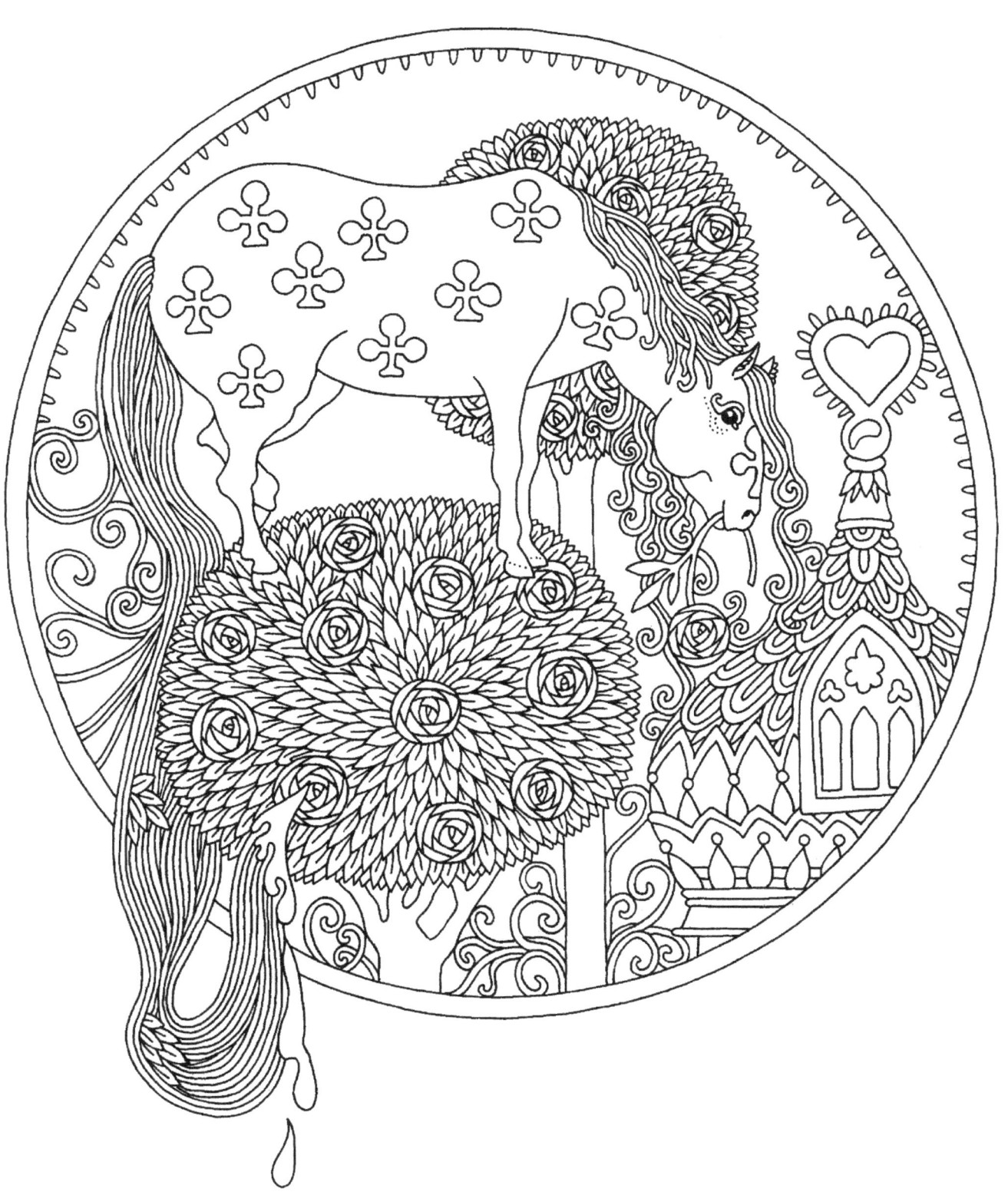

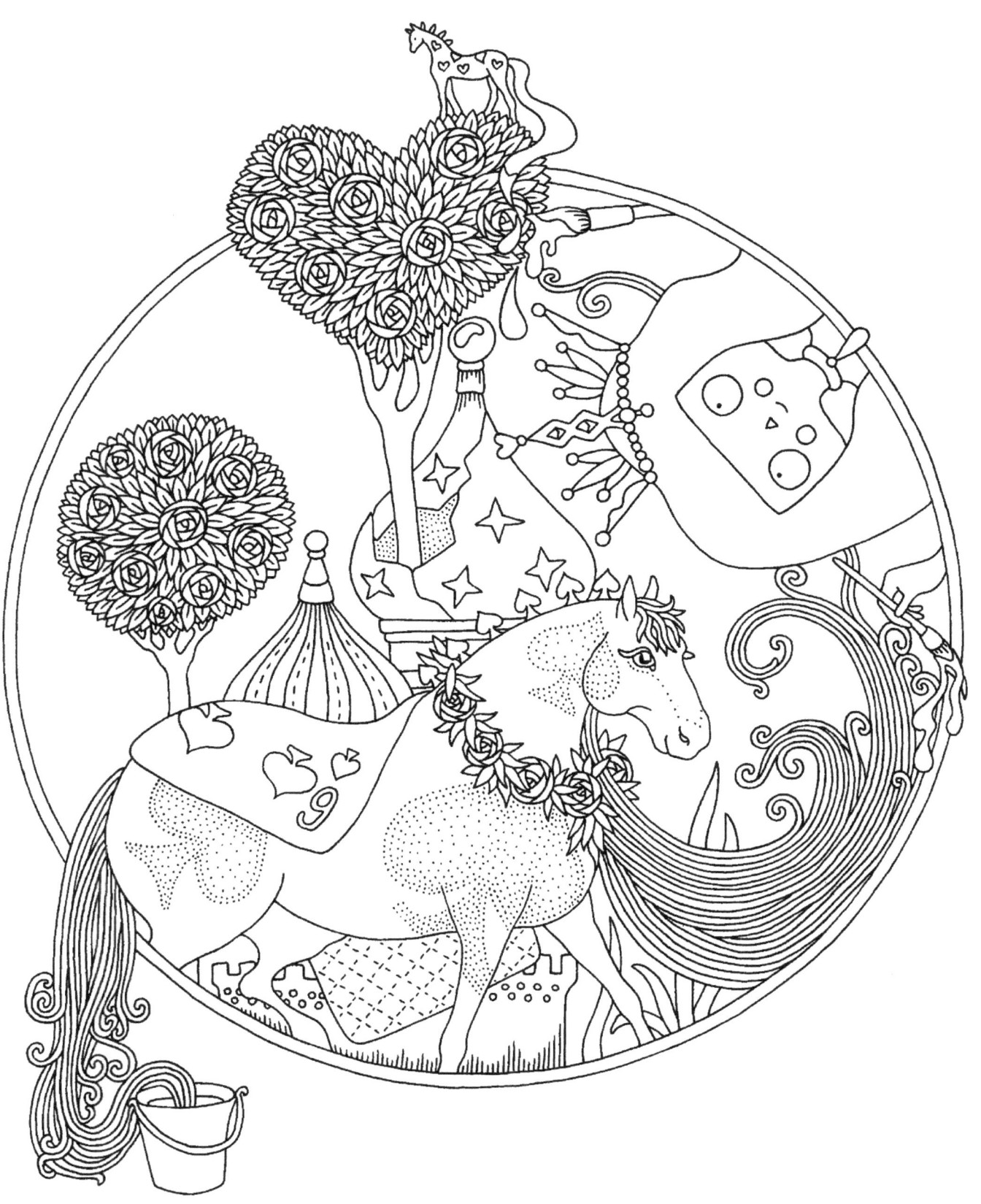

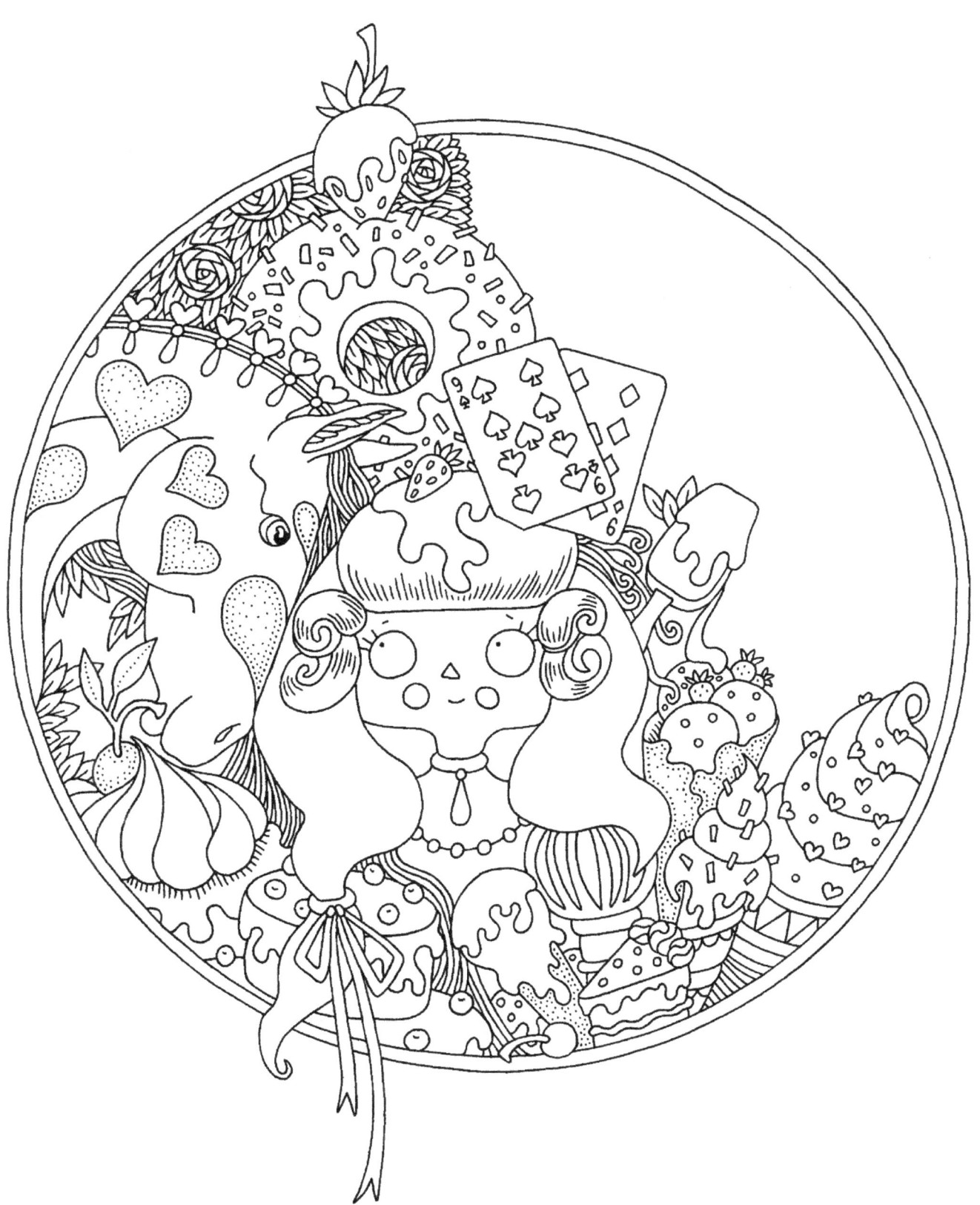

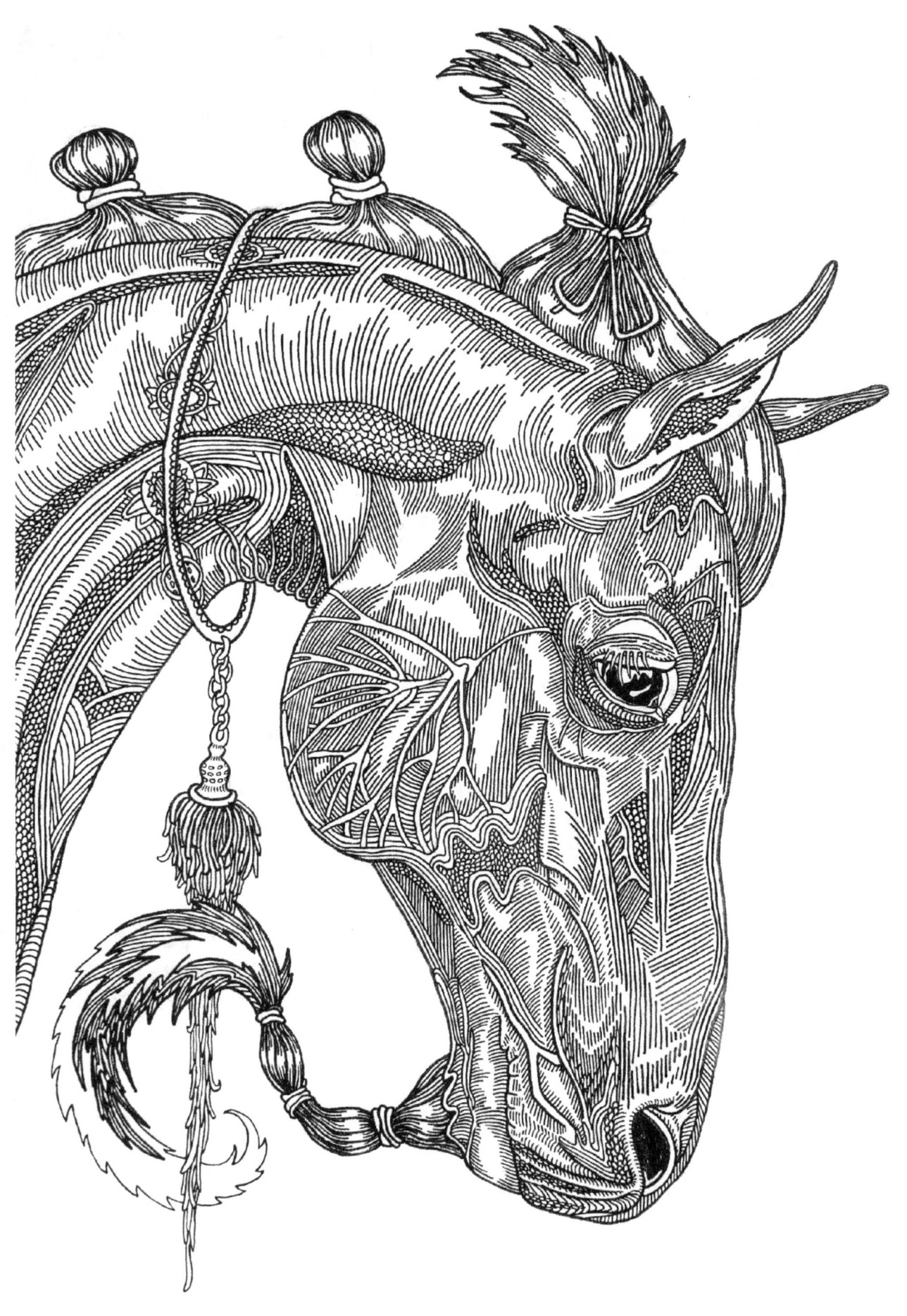

ABOUT THE AUTHOR

Olga Goloveshkina is a freelance artist and illustrator based in Moscow, Russia. She graduated from the Institute of Business and Design. Olga specializes in black ink doodles.

She is an author and illustrator coloring books for adults:
1. "The wind carries flowers"/"Veter unosit tsvety" (in Russian, 2015),
2. "Fox travel: Coloring book",
3. "Mounts" (in English, 2016),
4. "Mounts 2" (in English, 2016),
5. "Enchanted horses" (in English, 2016),
6. "Horse and Architecture" (in English, 2016).

Author page on Amazon:
amazon.com/author/olgagoloveshkina
Site:
http://olyagoloveshkina.jimdo.com
Instagram:
@olyahitrayapanda
@olyagoloveshkina

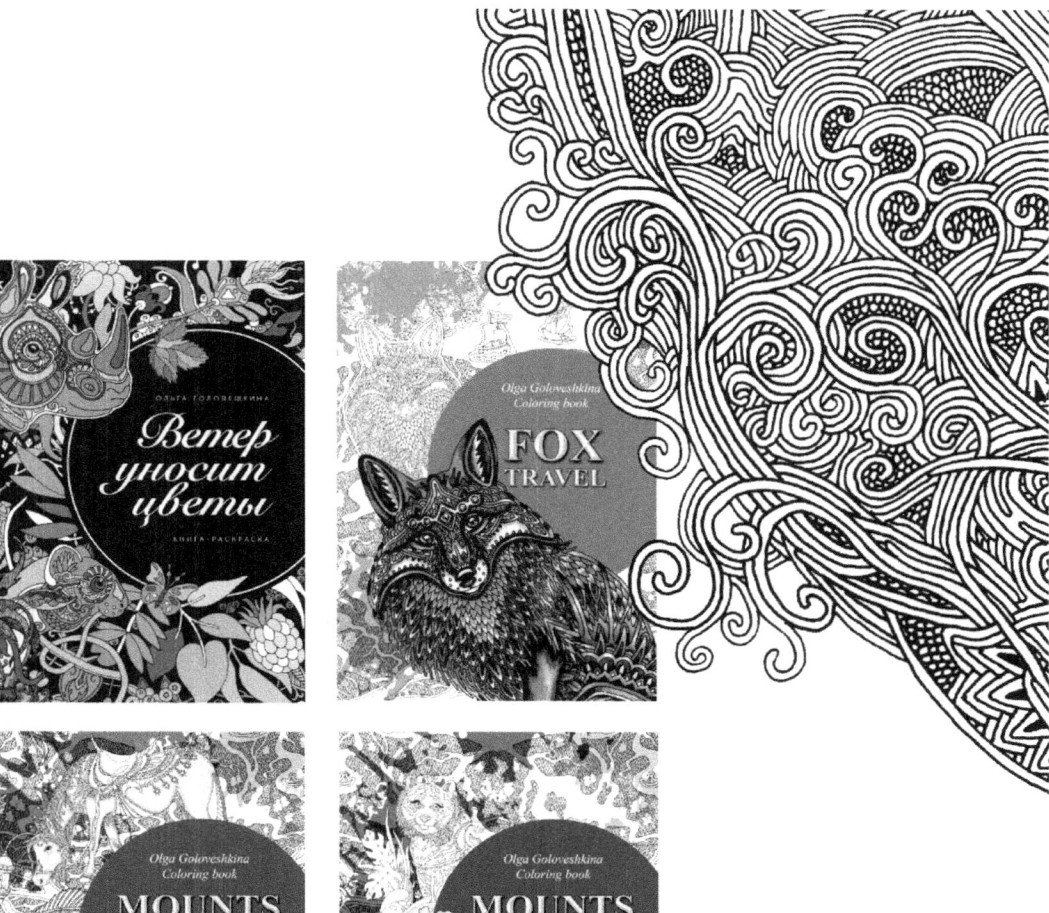
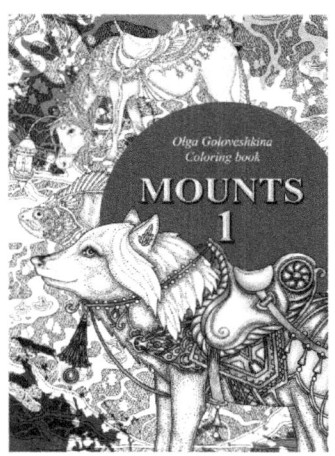
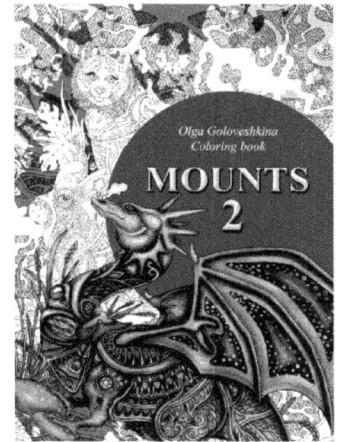
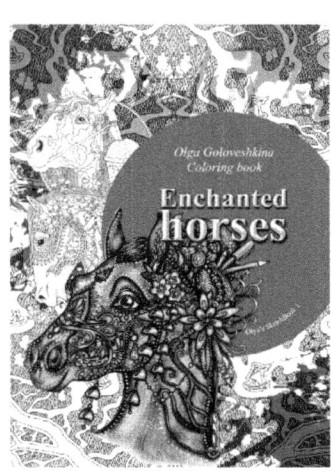